THE WORKBOOK

IMOGEN OWEN

A Practical Guide to Lettering:
Calligraphy Drills, Projects and Inspiration

PHOTOGRAPHY BY YUKI SUGIURA

Hardie Grant

QUADRILLE

CONTENTS

Introduction 4

How to use this book 6

What you need 7

Getting started 11

Using the guidelines 12

Letterforms 22

Confidence with scale 50

Words 56

STYLE

Experimenting and
developing your style 62

Mix and match 68

FLOURISHING

Basic drills 74

Look at letters 82

Composition 84

DECORATIVE ELEMENTS

Decorative drawing 90

Create your own wreaths
& decorative elements 94

Observational drawing 96

Adding a little bit of ink 100

Embellishing the ordinary 104

Getting festive 108

The perfect party 112

Adding serious style at home 118

Taking your skills outside 122

A letter to... 126

It's a gift... 132

Free and easy 138

WORKING WITH COLOUR

Mixing colours 146

Calligraphy appraisal 154

Troubleshooting 156

Glossary 157

Resources 158

Acknowledgements 159

INTRODUCTION

Welcome to *Modern Calligraphy: The Workbook*. I've created this book for you to use alongside my first book – *Modern Calligraphy Workshop* – or to use alongside your calligraphy practice. It's specially designed with a lay flat binding and quality paper that will enable you to write on it, in it and to, well, use as a workbook. Although it's been designed for you to write in, you can also use loose paper to work over the pages instead – it's entirely up to you.

Developing your calligraphy skills is ALL about practice, it's not something you will necessarily excel at in an afternoon. The wonderful thing about it is that practising it is a joy; it's meditative, relaxing and a brilliant way to switch off from our ever more screen-based lives.

I'm a self-taught calligrapher; I taught myself modern calligraphy nearly 10 years ago, and have never looked back. I am not, however, a classically-trained copperplate scribe, nor do I profess to be, so I'm not going to be teaching you formal classical calligraphy. What I do hope is that through practice and enjoyment of my calligraphy style, you'll develop a thirst for the craft and seek out and try more traditional forms as well. A broader knowledge of calligraphy styles will certainly help to develop your work and style and voice, too.

My first book has much more in-depth information about my style and technique, because this book is intended as a workbook companion. However, I wanted to make sure you have enough information to get started, so I have recapped the basics to help you feel confident you have the right tools for the job – from holding the pen correctly, to joining up words, to adding flourishes. This workbook is suitable for anyone, even if you've never tried any calligraphy before.

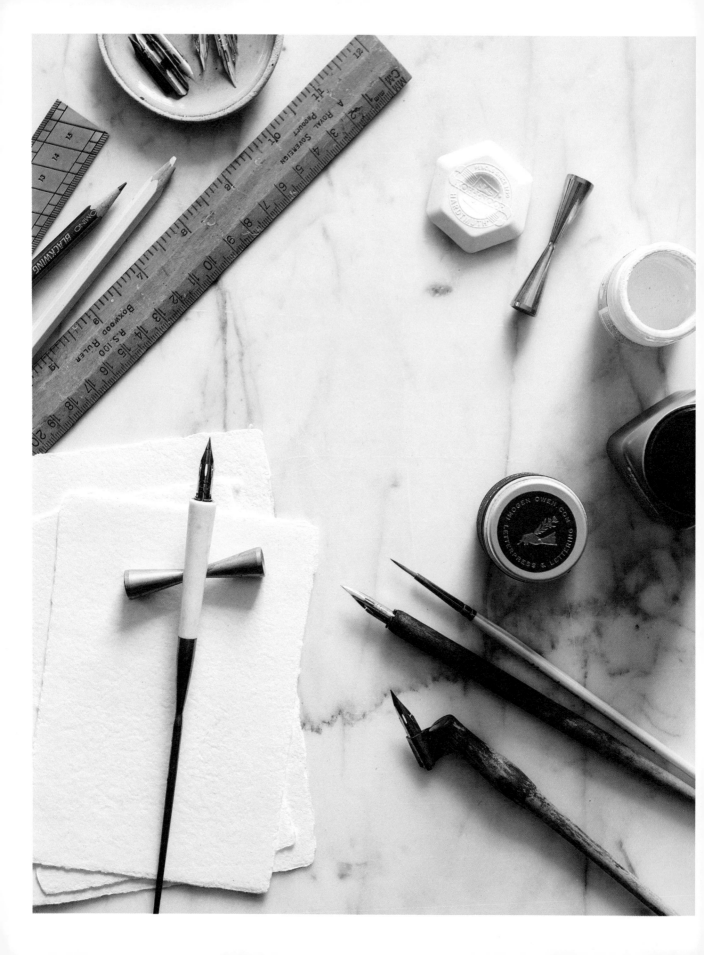

HOW TO USE THIS BOOK

I thought I'd explain how I'd recommend using this book. Although it covers many of the same basic elements as *Modern Calligraphy Workshop*, it has mainly been created for you to practise your work in. Hopefully it will be an inspirational space to practise in and an important part of your calligraphy journey, and become something of a keepsake of your experience of learning a new skill. The paper that it is printed on has been specially chosen to provide a beautiful-quality printed book and also to work perfectly for you to write in. I've tried and tested it with a few of my favourite inks, including my own home-made Iron Gall, as well as Higgins Eternal, Sumi and Winsor & Newton drawing ink. However, like any paper, if it's allowed to get cold and a little damp that may affect its resistance to the ink bleeding.

Although this book is designed for you to write in, I totally understand that you might not wish to do this straight away. If you'd prefer not to then you can always take loose sheets of paper and trace over the sections that you want to practise instead. To help you to get in plenty of practice – as I can't stress this enough, it's ALL about practice – I've made some of the guide pages available as downloads from the Quadrille website www.hardiegrant.com/uk/quadrille/moderncalligraphyworkbook, as well as from my own website.

If you do write directly into this book then be aware that you will need to allow your ink to dry before turning the pages! If you are too busy to wait, you can always try blotting* any work that's still wet.

*See Glossary on page 157 for more details.

WHAT YOU NEED

It's always important to have the correct tools for the job, and fortunately the kit needed to start your calligraphy practice is pretty inexpensive. You will need a penholder, nib, ink and this book / some additional practice paper, a water pot and some paper towel.

PENHOLDERS

A basic straight wooden penholder will suffice to get started, as it works well for both right- and left-handed writers. An oblique (angled) penholder is more commonly used by right-handed writers because it angles the nib to help achieve the slant associated with copperplate calligraphy. Left-handed writers tend to achieve this slant naturally when working, so the oblique penholder can be harder for them to work with.

INK

I would always favour practising with a black ink, although you can use whatever you like. Iron Gall – a traditional ink used since medieval times – is one of my favourites, along with Higgins Eternal ink, or Sumi ink.

I'm not the neatest human on the planet and will readily admit this, so I would always recommend when practising that you place the pot of ink on a saucer, paper towel or some other form of protection. Most black ink will stain in some way or other, so I suggest having something under your paper on your work surface to avoid marks, even if you just place it on a spare piece of paper!

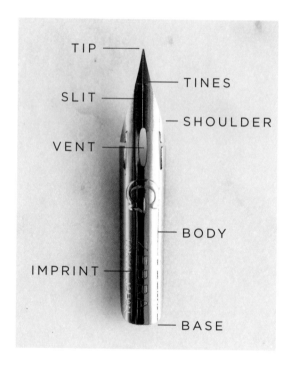

NIB

You can practise this style of calligraphy with any nib that's suitable for copperplate and pointed pen calligraphy, so the key is to stay away from any of those broad, wide-ended nibs you might see around – that's a totally different style of calligraphy! If you're unsure which nib you're looking at, the name of the nib is usually written on it, so you can check here – see the imprint as shown on the image above.

My recommended choices for starting out are below. The key is to find something that is quite firm with a nice flexibility. Firm because when we start out, we tend to be fairly heavy-handed with our technique whilst getting confident with it, and a firm nib will take heavy-handed use and still give you a nice result. A much more flexible nib will be far harder to get a good result from to start with, and you may find yourself getting disheartened needlessly.

Firmer:
Zebra G, Nikko G, Tachikawa G, Brause 361 Steno, Crown

Softer:
Brause 66EF, Hunt Imperial, Gilot

Different nibs and the way they feel may also change your style slightly. I find they have different personalities; with some nibs my style is more minimal and sparse, with some I find myself more flourished, so I tend to work with different nibs according to the work I'm looking to do. Mostly you'd use different nibs depending on the surface you wish to write on, as something with a super-sharp firm nib is going to be much harder to use on a more fibrous handmade paper, than something a little softer and more flexible. It's all a matter of practice and experimentation to find out which you like best. I started with Nikko G nibs, and I tend to work predominantly with those and Zebra G nibs. Some people like to start out with the Brause Steno nibs. The beauty of calligraphy is that getting an assortment of nibs isn't going to cost you very much, so I'd recommend getting a range of nibs to start and see what you like working with and how they all feel.

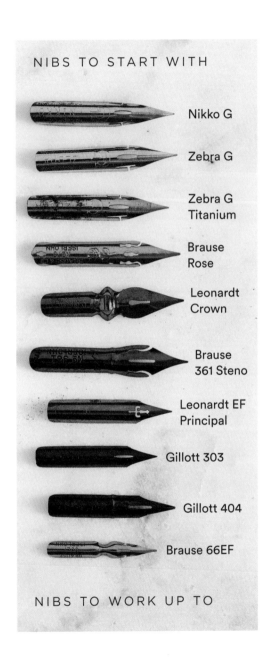

NIBS TO START WITH

Nikko G

Zebra G

Zebra G Titanium

Brause Rose

Leonardt Crown

Brause 361 Steno

Leonardt EF Principal

Gillott 303

Gillott 404

Brause 66EF

NIBS TO WORK UP TO

PENCIL

It's actually great to practise with a pencil, especially a slightly softer one like a 2B or softer (the higher the number the softer the pencil, so 6B is really soft) as opposed to an HB pencil. You can get a darker, softer line by adding a little pressure, and keep a fine line when not exerting pressure. Using a pencil to practise is a good way to work at your shape formation, as you don't need to worry about the ink.

I would certainly recommend working with pencil when practising in this book, as well as with pen. I've included some warm-up exercises to do in pencil, but I would also encourage you to try any of the exercises in pencil as well as in pen; it's a great way to practise if you're somewhere where it's going to be harder to whip out a pen and a pot of ink.

CLEANING UP!

If you have to stop for a short time mid-practice then try and dip your inky nib into your water pot and wipe it clean on a paper towel, because it's much better not to leave ink to dry on a nib.

When you've finished for a session, give your nib a thorough clean with water, removing it from your penholder and cleaning and drying it all over. Then you can put it back in the holder knowing it's ready for when you want to use it again.

A little toothpaste works well for cleaning nibs if you want to give them a little more thorough clean. It's so important always to look after your tools and pack up properly, because there is nothing worse than coming back to practise all enthusiastic, only to find bits missing or dirty and rusting.

GETTING STARTED

POINTED PEN TECHNIQUE

Pointed pen technique is a little unusual when you first start to learn, as it's all about pressure. You'll be working with two weights of line: your fine 'hairline' strokes and thick downstrokes. The fine hairline strokes are the thin lines that you'll create using the nib with no exerted pressure, and the thick downstrokes are the lines you'll make by exerting pressure on the nib so that the tines at the end splay apart and the ink is laid down in a thick section. It's an unusual thing to practise at first, as we are all used to writing with one consistent hand pressure; whether you are heavy- or light-handed, you don't tend to vary what you do whilst writing. But with this technique, you aim to make thick downstrokes by exerting a slight pressure on the nib, and fine upstrokes by taking off any pressure. We all find this a bit tricky to master at first, but once you've got it, it will become a part of your muscle memory and you won't even think about it. The key is in understanding that it's a quite nuanced amount of pressure – you don't need to put all of the weight into your hand to achieve it, but instead learn the lightness of touch required to achieve different line weights. When starting out it's normal to be bit heavy-handed, and to move from one extreme to the next, but with a little practice you will start to sense the required subtlety of touch.

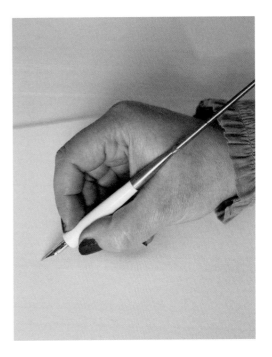

Hold your pen lightly between forefinger and thumb as shown above. Try not to grip the pen too hard, everything you do should feel nice and relaxed. Keep your hand and arm soft so you can make fluid movements.

USING THE GUIDELINES

In this workbook I've left you plenty of space to practise what I'm showing you along the way, if and when you want to write on the pages. The amount of practice space varies throughout the book, and to help you understand why it looks the way it does, I'm going to explain in a little more detail how the structure and proportions of letters in calligraphy work and how we can use guides to help keep some structure and form.

One of the things that I love most about 'modern' calligraphy is the fluidity and organic spirit of the lettering, and that it doesn't stick too strictly to set grids. However, in order to achieve this freedom, you actually need to have an understanding of the way the letterforms are structured, which is based on the traditional copperplate calligraphy from which my style and most other modern styles have developed. Once you understand these proportions, you can play around with them and explore how experimenting with them can help to create different character and style to your letterforms.

Using guidelines will help you to work on the proportions of your letters; different forms of calligraphy will use different proportions. The guidelines help to balance the shape and form of the letter, so there is a proportion for the body of the letter relative to the ascender (stem going up on an h, k, l, etc.) or descender (stem going down on a g, j, y, etc.). Since this book is more about helping you to get a taste and to work on my style of modern calligraphy, I don't focus as much on proportions as you would if learning traditional copperplate because my work isn't as fixed. However, it's always worth looking into proportion in more detail if you want to develop your work. Having an understanding of proportions will help your letter formation, even if you then don't adhere to it so strictly.

The ratio of these guides can vary but they are really easy to work with. When you are new to this style of calligraphy, guides will help to prevent you from reverting to your own handwriting proportions, so it's good to practise using them. You might find that as you progress you don't want to use them any more, but I always recommend them to help establish traditional proportions so in some parts of the book you'll find guides to practise on; some just have a baseline and some a baseline and an x-height as a starting point to work with.

This is the line to guide you as to the height of your ASCENDER (the stem of a letter going upwards, such as the stem of an h, b, d or an l or t, etc.).

A

exit stroke

x - height

baseline

X

The baseline, this line, is the same as the line you would use on a piece of lined notepaper. It's the line that everything is based on and sits on. The x -height very literally shows the height of a lower case x sitting on the baseline. The x-height also helps to define our proportions as the body of the other letters are going to sit in this space, with the ascenders and descenders reaching above and below.

D

entry stroke

This is the line to guide you as to the length of your DESCENDER (the tail of a letter going downwards, such as the tail of a g, p or y.

WARM-UP EXERCISE AND BASIC SHAPES

Warming up and getting comfortable with the techniques needed is certainly important. One of the key things to understand when starting on your calligraphy journey is that it's not about writing. It really doesn't matter if your handwriting is barely legible – this doesn't mean you won't be able to do calligraphy because it's simply not the same thing as handwriting. It's far more easy to understand if you think of it as drawing letterforms; drawing shapes that when combined together take the form of letters, which isn't exactly the same thing as 'writing a letter'.

In order to become accomplished at creating beautiful letterforms, you need to practise the foundations, the basic shapes that are used to construct letterforms. Once you get these firmly established, everything else will fall into place. Good formation of these basic shapes is what's going to make ALL the difference in your work because if you don't get the basic shapes you use right, then all the letters you construct with them will look badly formed. It's always good to come back to these and practise them. The quality of the lines you create will also determine the quality of your work.

Whilst we all want to race ahead and write our name in new fancy calligraphy (you're all going to do it, so it's totally fine), please come back to this section and keep practising until you have consistent thick downstrokes and super thin upstrokes, and smooth curves and ellipses. Keeping control of your line quality is super important, as that's what allows you to end a line in a beautiful form, as opposed to meandering to a flat finish, and is going to set you and your work apart.

The next few exercises are all about getting used to thick and thin strokes, and the basic shapes used to construct letterforms, and learning how to master smooth transitions.

PENCIL PRACTICE

Practise in pencil. It's always useful to practise your mark-making and creating forms in pencil before using pen, because then it's easy to focus on the shapes without worrying about running out of ink, and because pencil is more immediately familiar than working with a pen and nib with pressure. Have a go at making these basic shapes with pencil. Relax and let the pencil flow around the forms and just start to feel your way around the shapes, getting smooth curves and figures of eight. This is also good for getting you to start thinking about the weight and pressure you naturally apply with your hand. If you use a very firm pressure you'll find it harder to flow over the surface of the page, so it's a great idea to start thinking about the level of resistance you get from the paper!

INK PRACTICE

Now we're ready to move onto practising basic forms using pen and ink, so we're going to build on what you've just been doing in pencil. The key is to remember that the downward strokes are going to be where you add a little pressure, enough to split the tines of the nib and create a thick stroke. The upward strokes are where you're going to be taking any pressure off and be as light as you can, creating a lovely thin stroke. You're looking to create a good contrast in line weights. If you are too firm on the upstrokes you'll find it much harder when making any curves or arcs, as you'll find you get stuck and snag on the page. Most importantly, don't be hard on yourself if you have shaky lines on your upstrokes – that's part of the learning process and they will smooth out with practice! Make sure you keep your nib facing up and don't be tempted to turn it whilst working. It should always stay facing up.

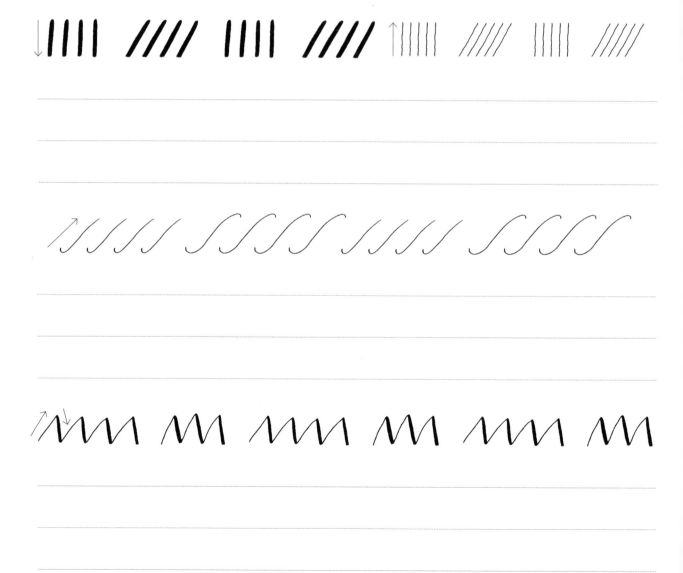

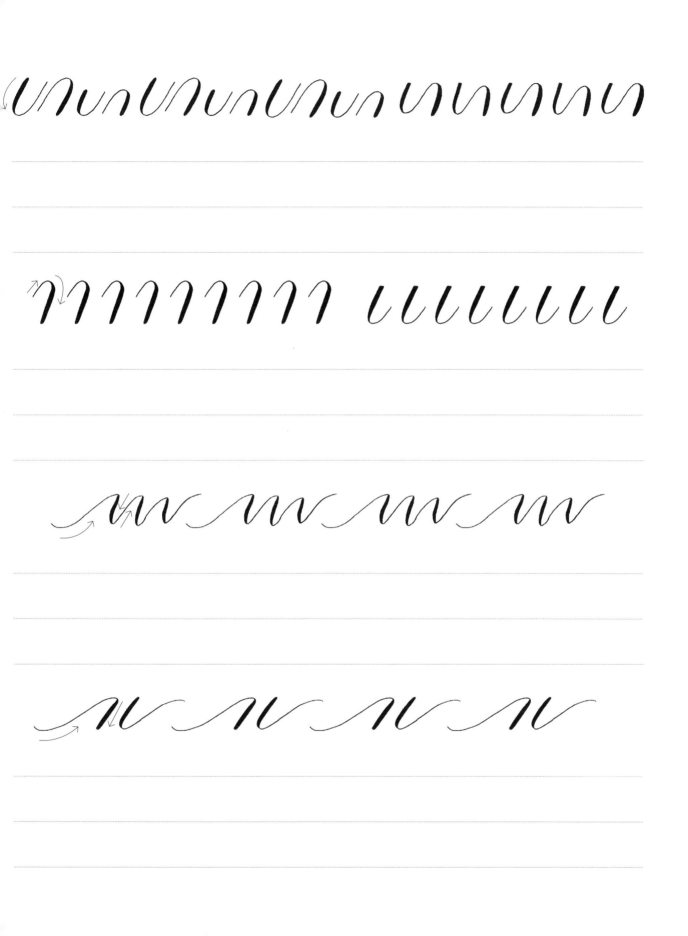

CCCCCCC OOOOOOO

Oo Oo Oo Oo Oo CCCCCC

Well done – you should be starting to feel a bit more confident now with your pen and ink, and be starting to get used to using the variable pressure!

LETTERFORMS

On the following pages is a basic modern calligraphy alphabet – it's one of my lettering styles, and it's time for you to get familiar with it. Start by writing over the greyed-out letters to feel your way around it and then you're on your own!

Feel free to write directly into the book or to use some blank paper and trace, it's entirely up to you. Remember that your upstrokes are always thin strokes, and your downstrokes are always thick! Take your time and feel your way around the shapes; try to think of them more as shapes than letters. If you are too firm on your downstrokes you'll find it harder to move around the page and transition from thick strokes to thin strokes.

When teaching, one of the things I often get asked is 'how to join a p and a p' or other combinations, and I think it's really useful to get into the habit of practising all the possible letter combinations. Doing this will enable you to become familiar with them so when you are writing out sentences and words you'll be less hesitant. Often when you hesitate and are unsure you lose your flow, and your spacing can become erratic as you move between letters you're confident with and struggle with those you are not.

The next section has a page devoted to each letter as a majuscule and minuscule – the calligraphy terms for upper and lowercase. There are a few examples of letter combinations, too; I've included examples of most shape-to-shape combinations, and I would suggest that you practise every letter combination – a to a, a to b, a to c, etc. – once you have completed this section.

A A A

a a a

aa aa ae ae af af ah ah av av

am am ar ar ap ap as as ay ay

a a a a a a A A A

A A A A A A A A A A

A A A A A A A Ae Ae

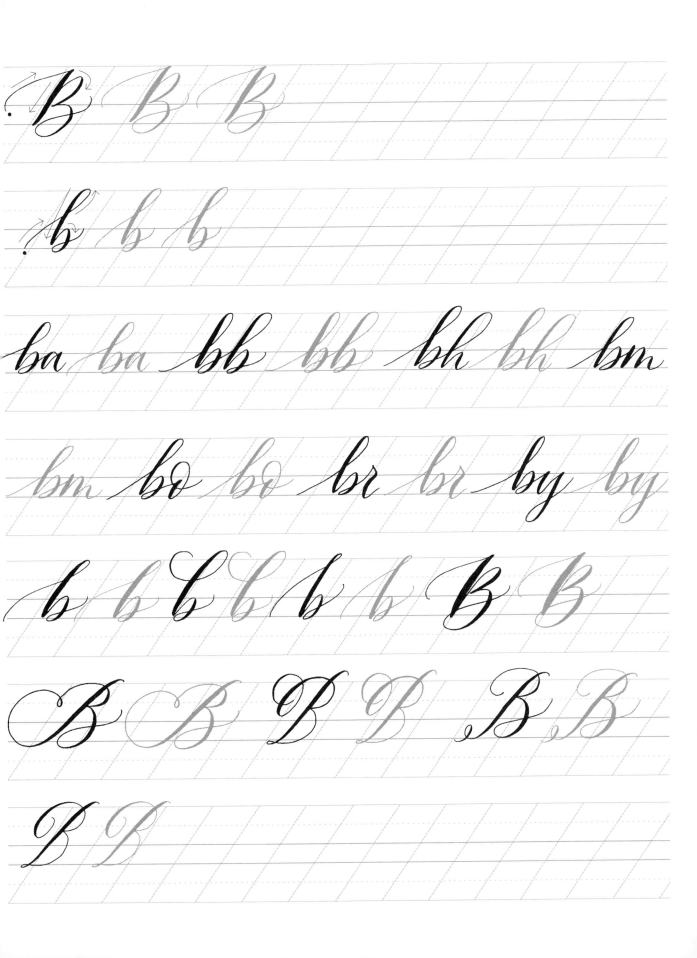

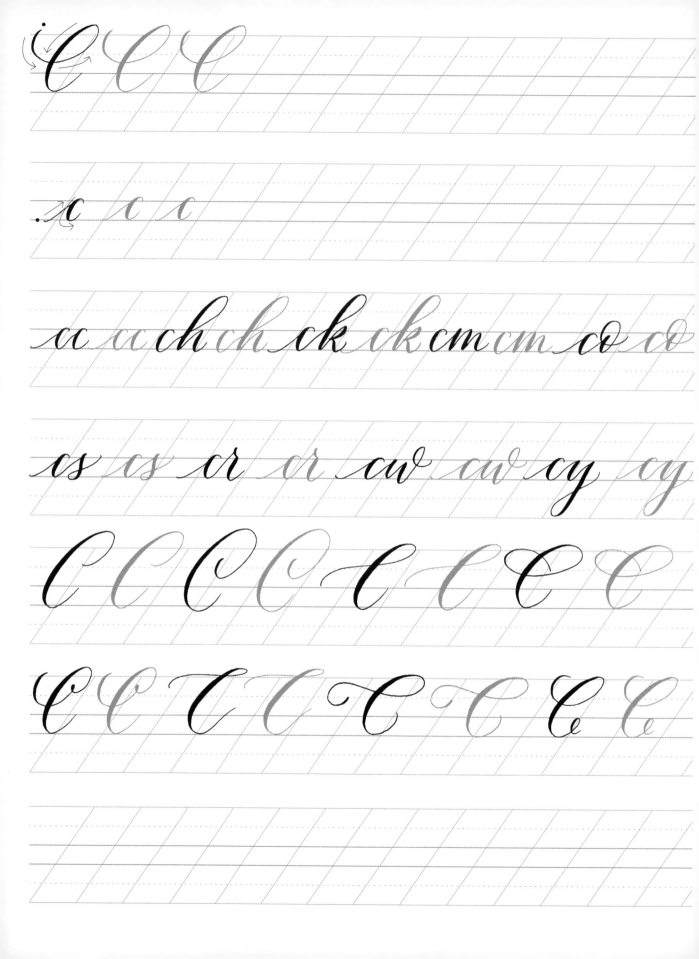

C C C

x c c

cc cc ch ch ck ck cm cm co co

cs cs cr cr cw cw cy cy

C C C C C C C

C C C C C C Ce Ce

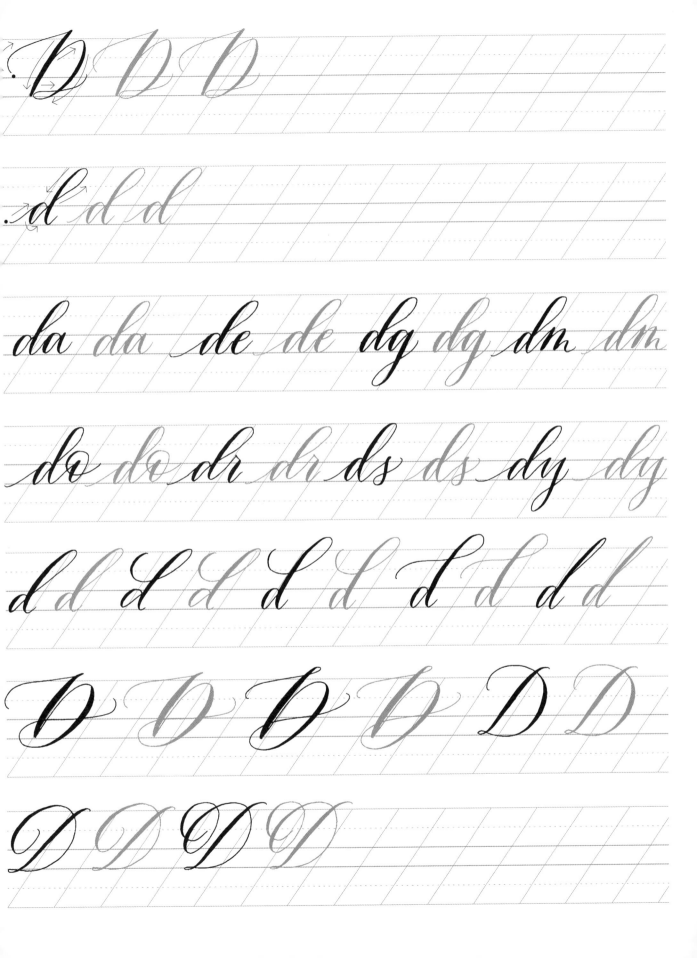

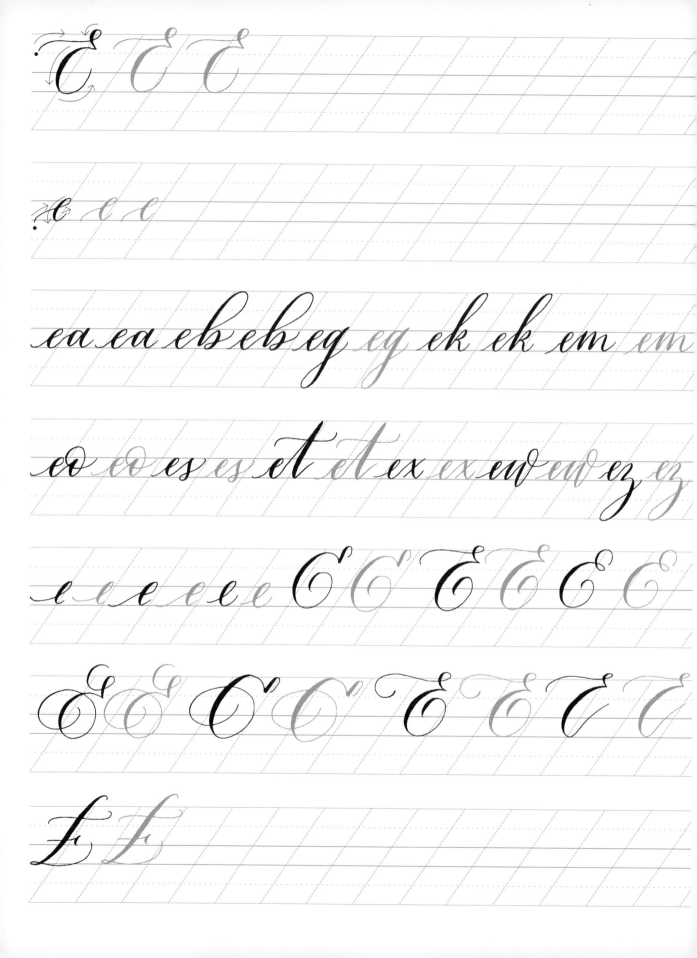

ℰ ℰ ℰ

e e e

ea ea eb eb eg eg ek ek em em

ev ev es es et et ex ex ew ew ez ez

e e e e e e ℰ ℰ ℰ ℰ ℰ ℰ

ℰ ℰ ℰ ℰ ℰ ℰ ℰ ℰ

ℱ ℱ

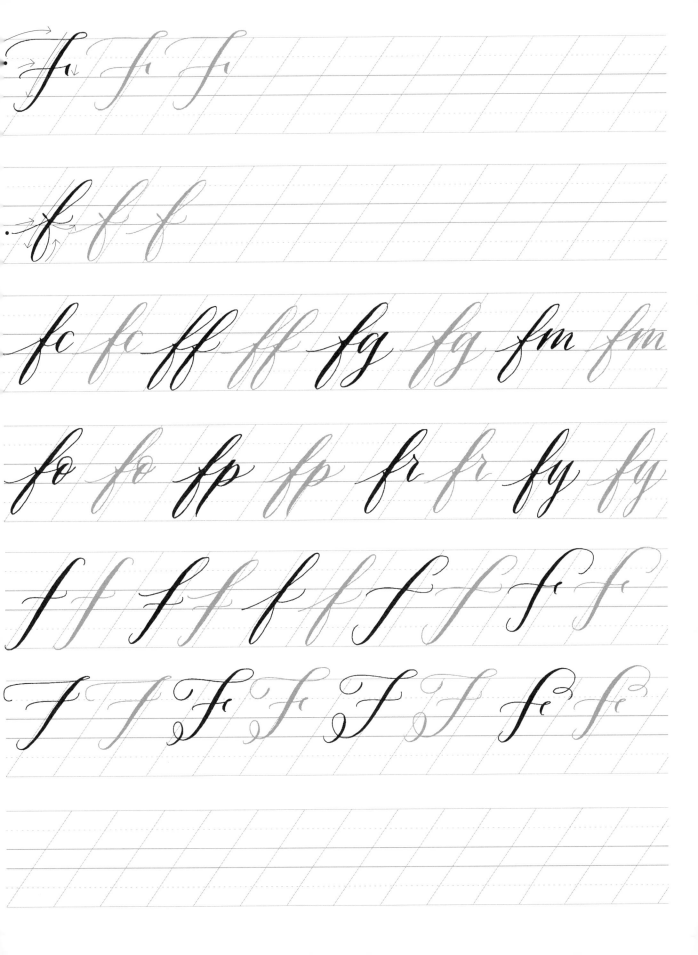

G G G G

g g g

ga ga ge ge gh gh gm gm go

go gp gp gr gr gs gs gt gt

g g g g g g g G G G G

G G G G G G G G G

G G G G G G G

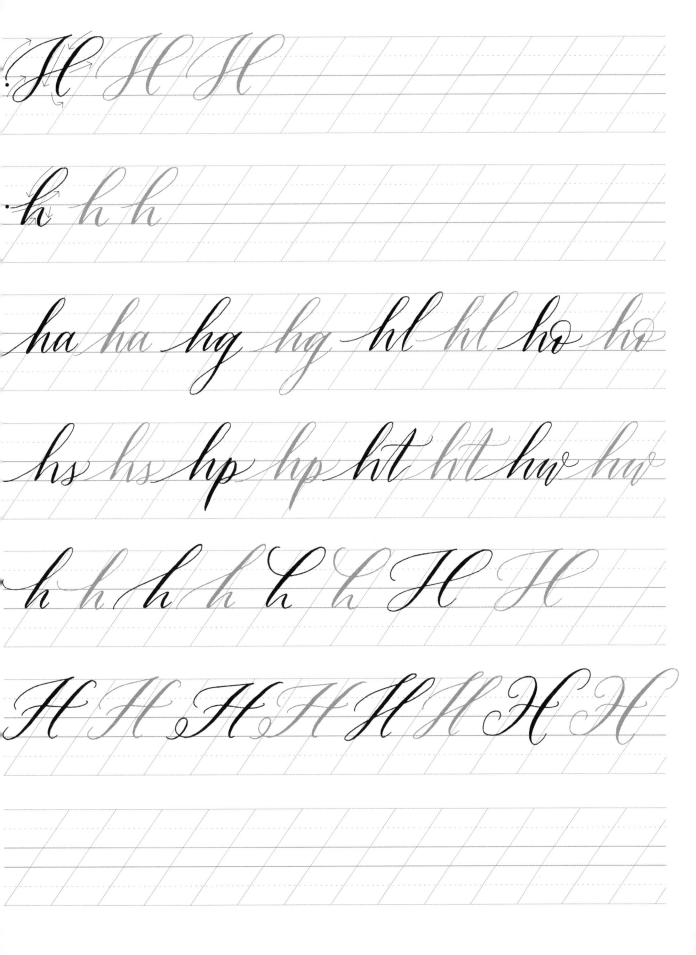

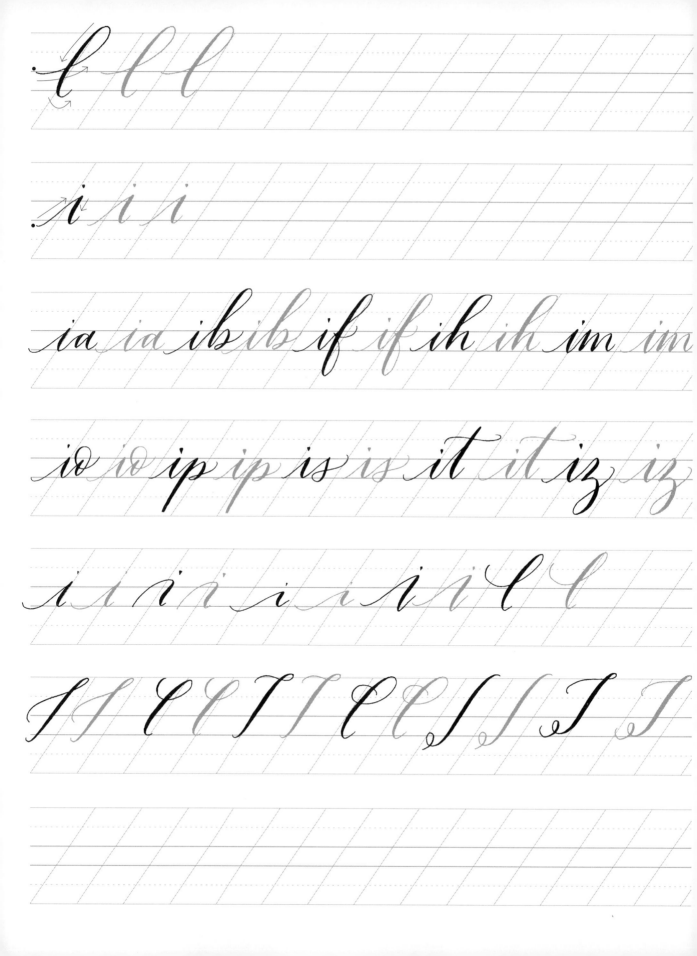

l l l

i i i

ia ia ib ib if if ih ih im im

io io ip ip is is it it iz iz

i i i i i i i i l l

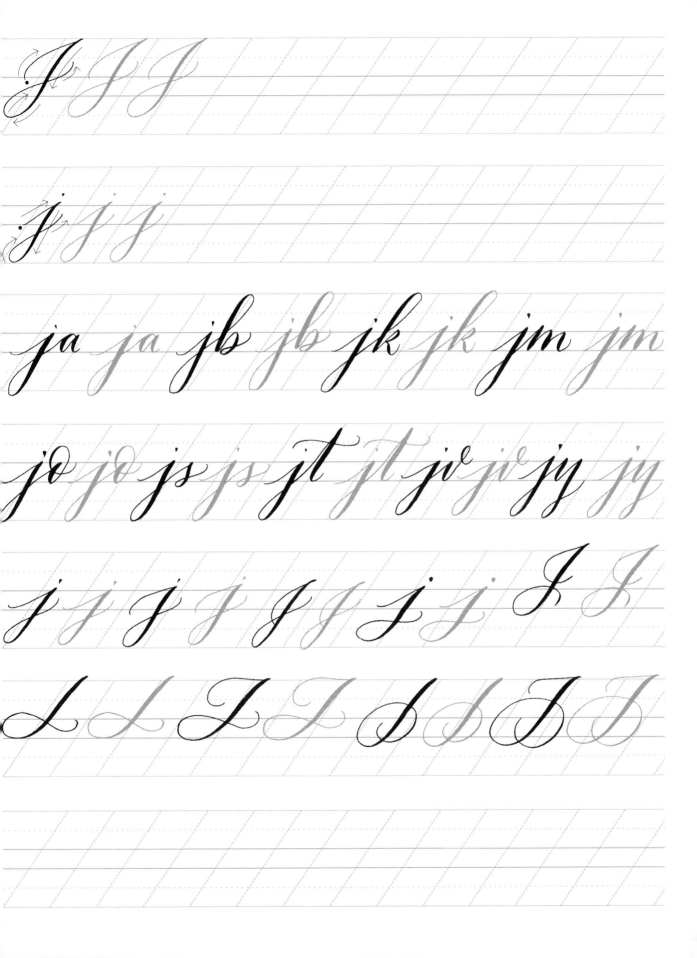

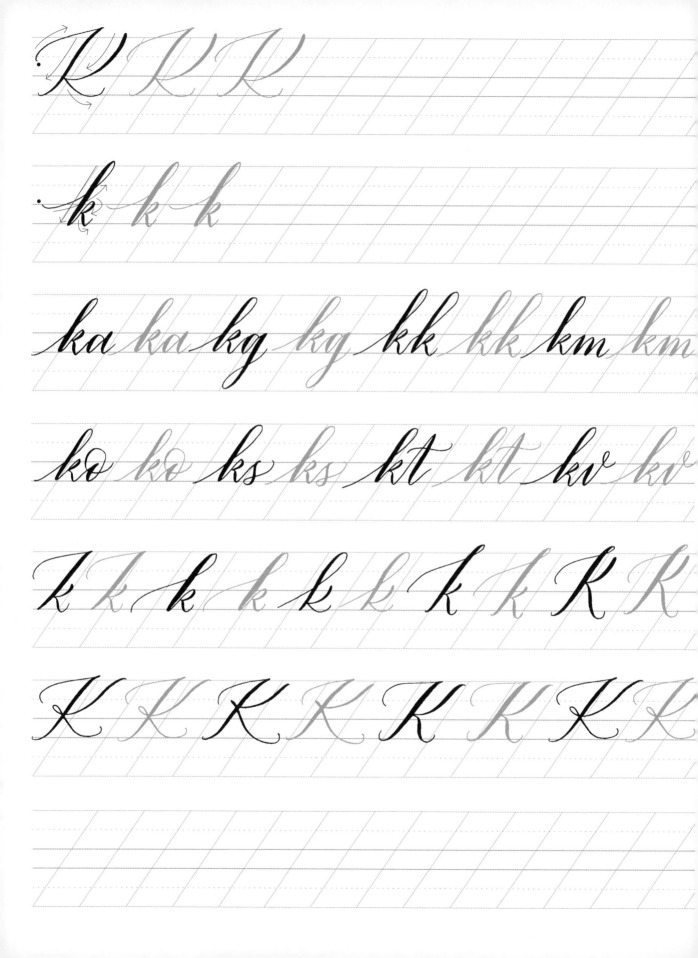

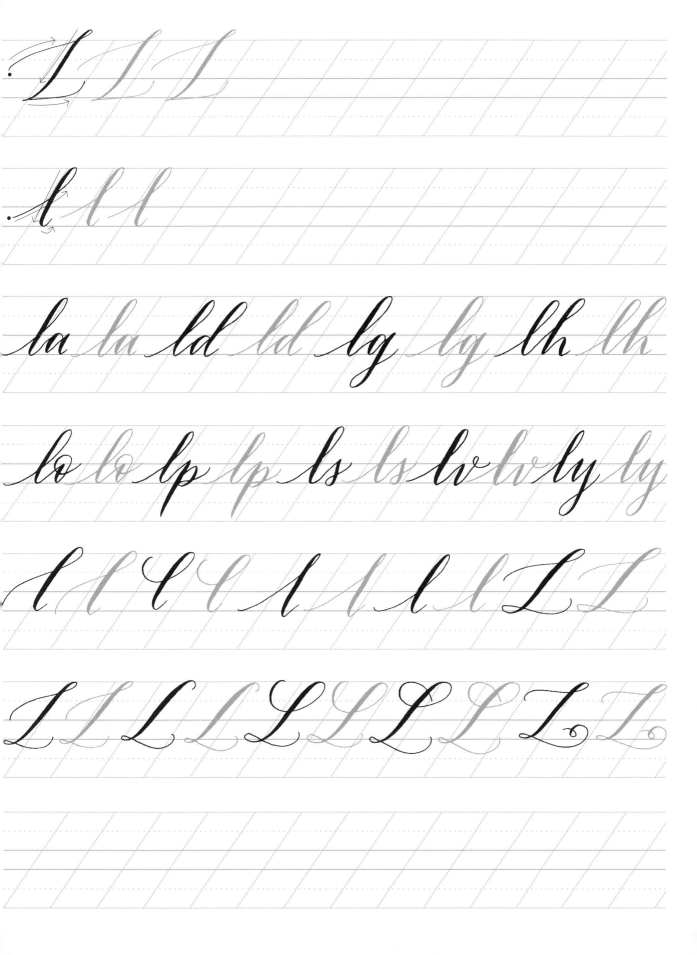

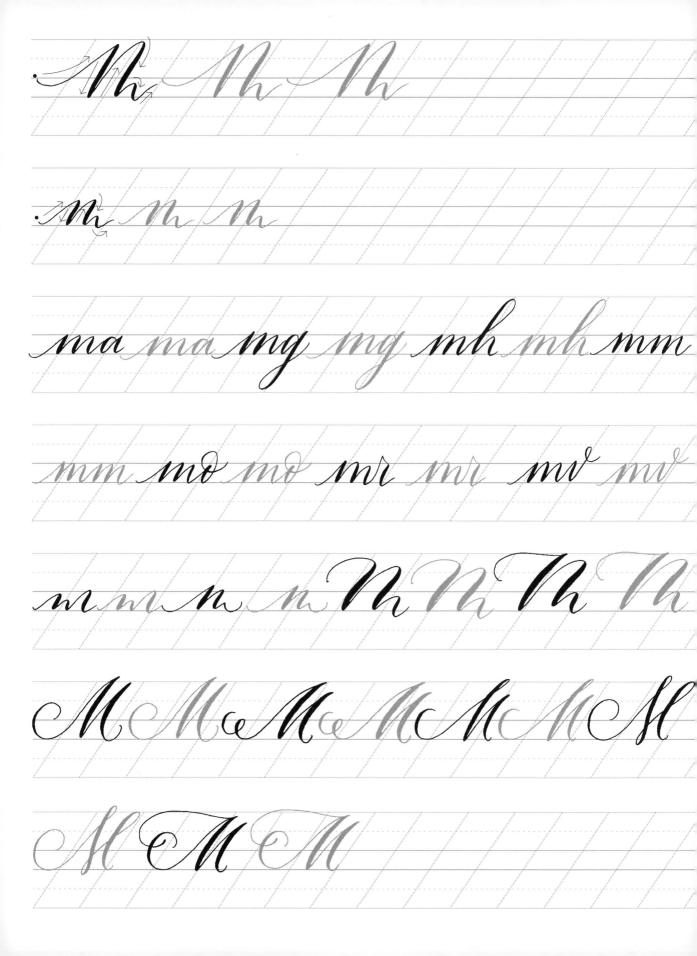

N N N N

n n n

na na nf nf nh nh ng ng no

no np np nr nr ns ns nz nz

n n n n n n n n n n

N N n n n N N N

N N N N N N N

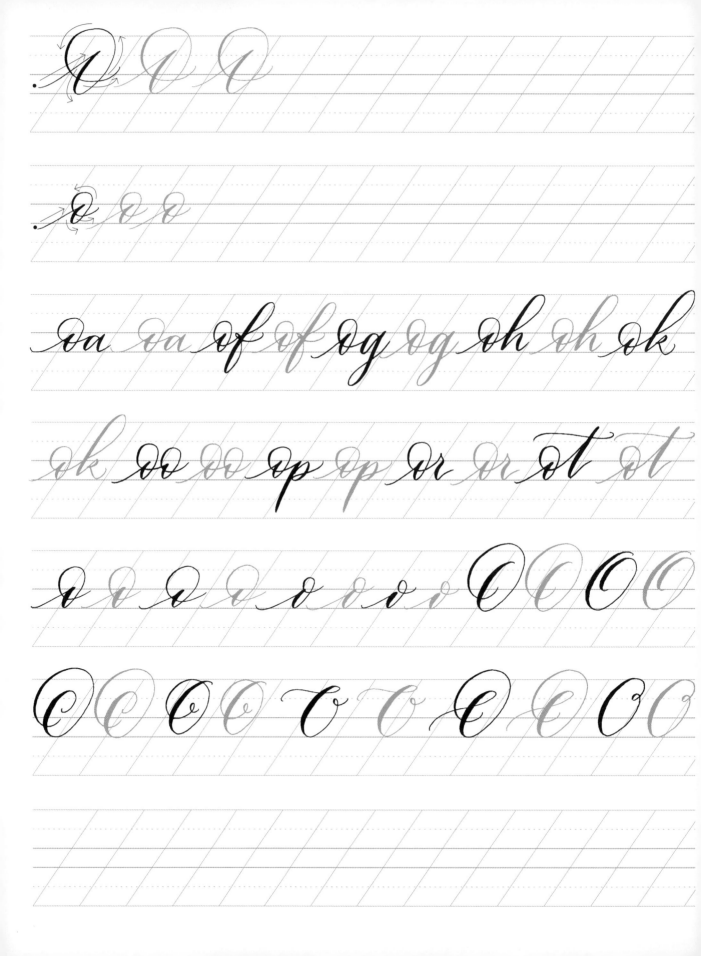

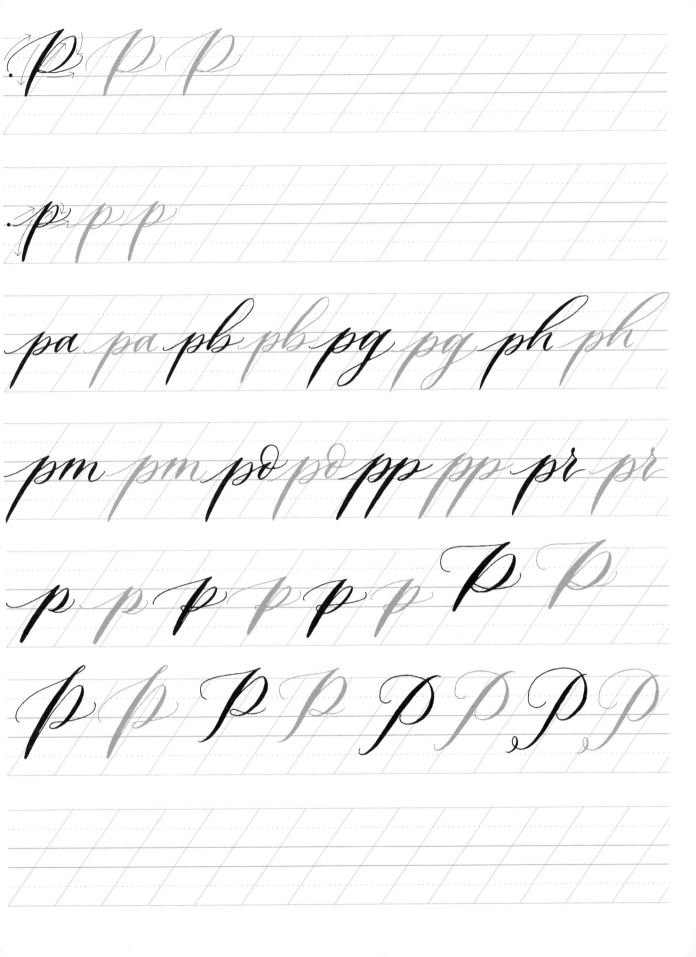

p p p p

p p p p

pa pa pb pb pg pg ph ph

pm pm pd pd pp pp pr pr

p p p p p p p p

p p p p p p p p

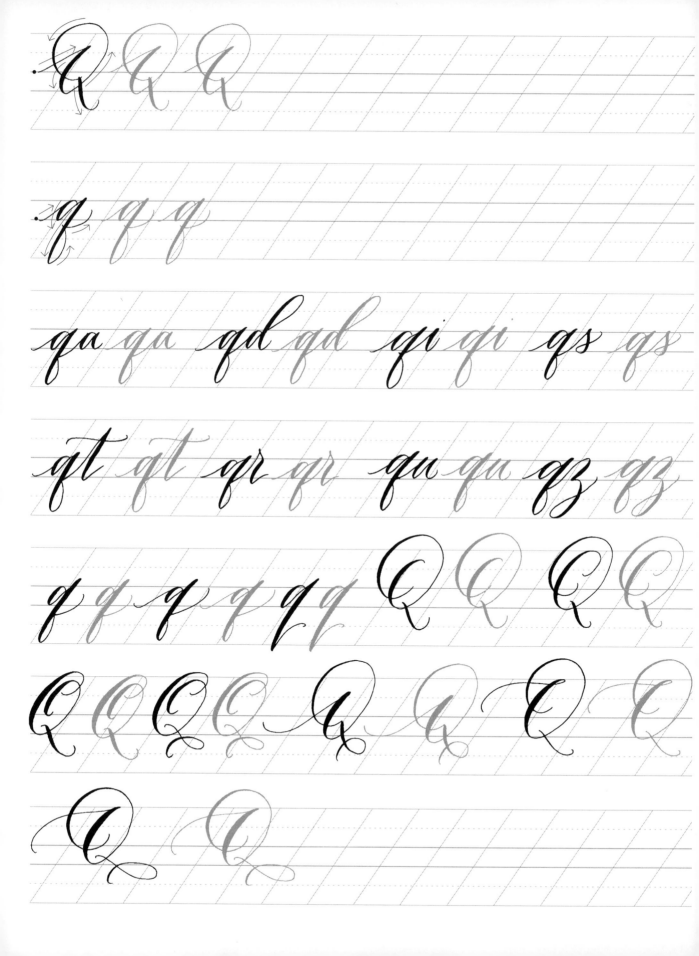

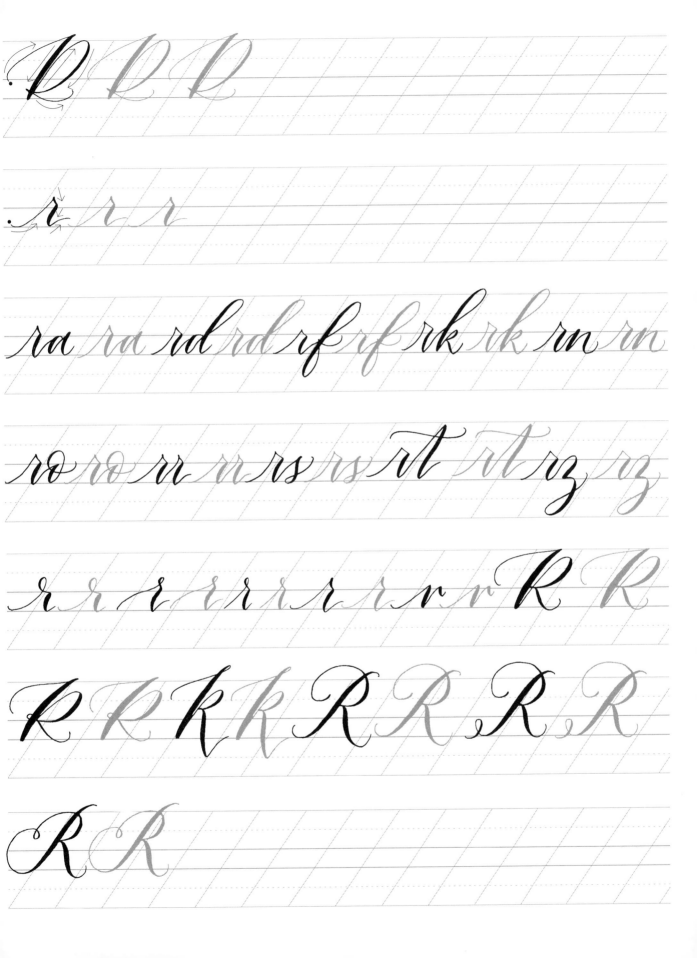

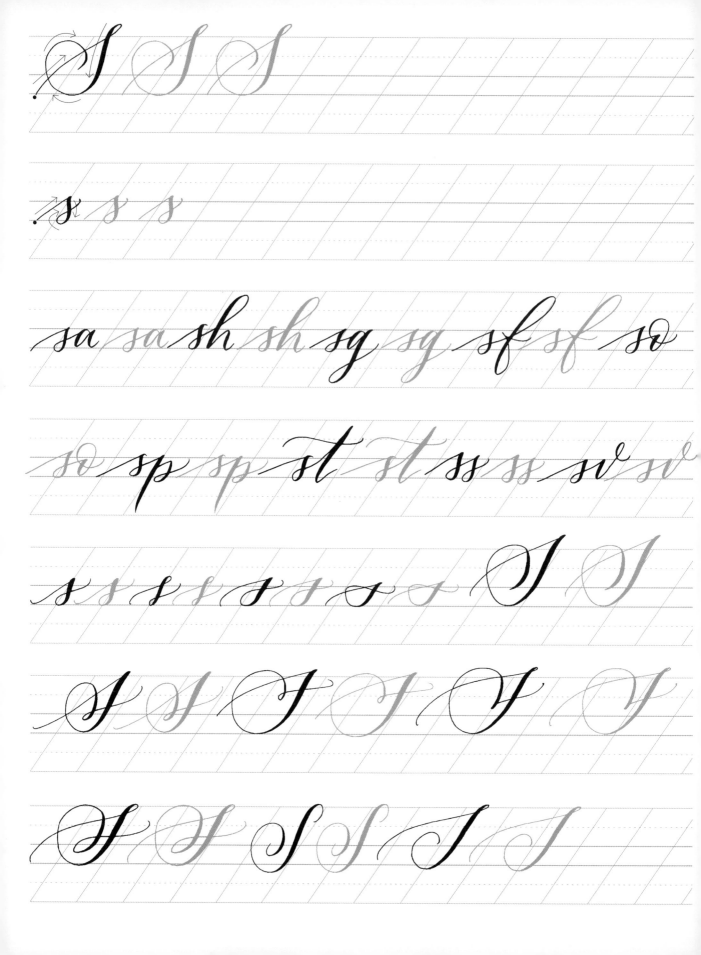

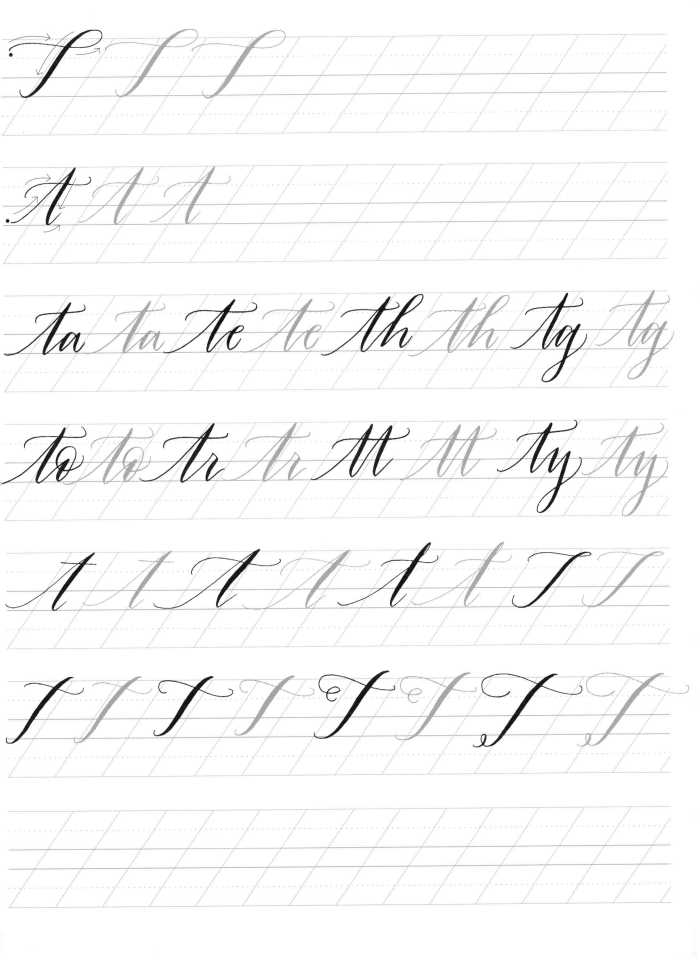

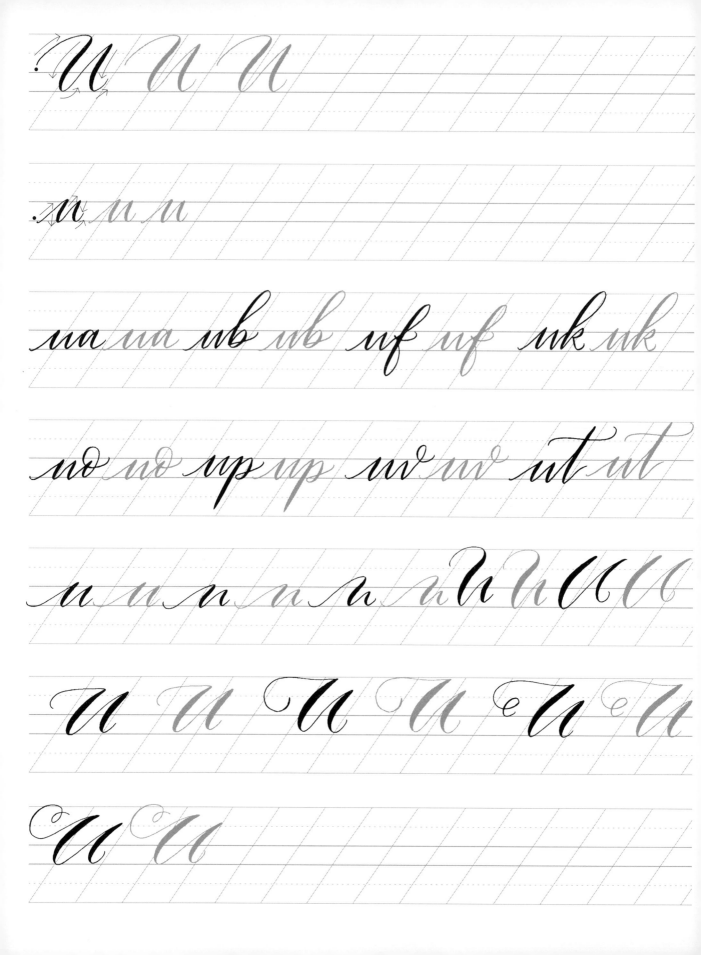

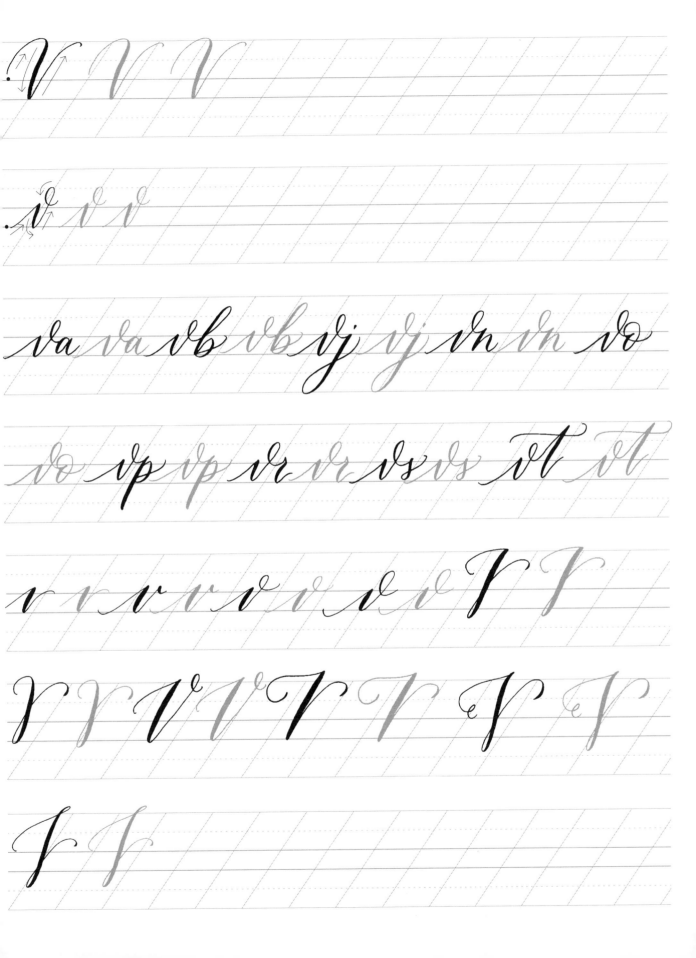

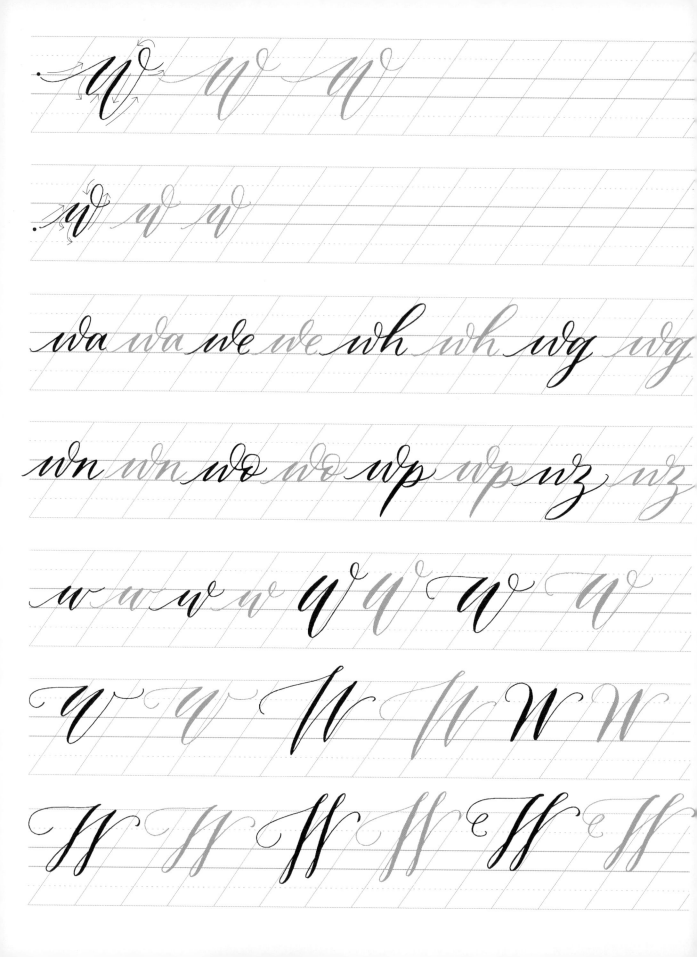

wa wa we we wh wh wg wg

wn wn wo wo wp wp wz wz

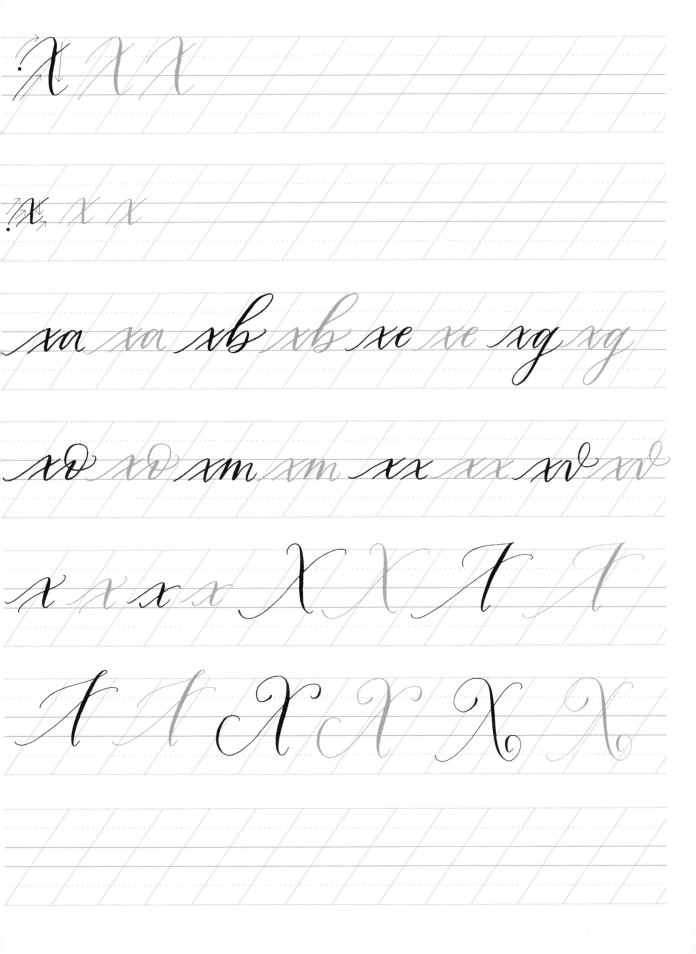

Y Y Y Y

y y y y

ya ya yb yb yg yg yk yk

yo yo yr yr yt yt yv yv

y y y y y y y y Y Y

Y Y Y Y Y Y

Y Y Y Y

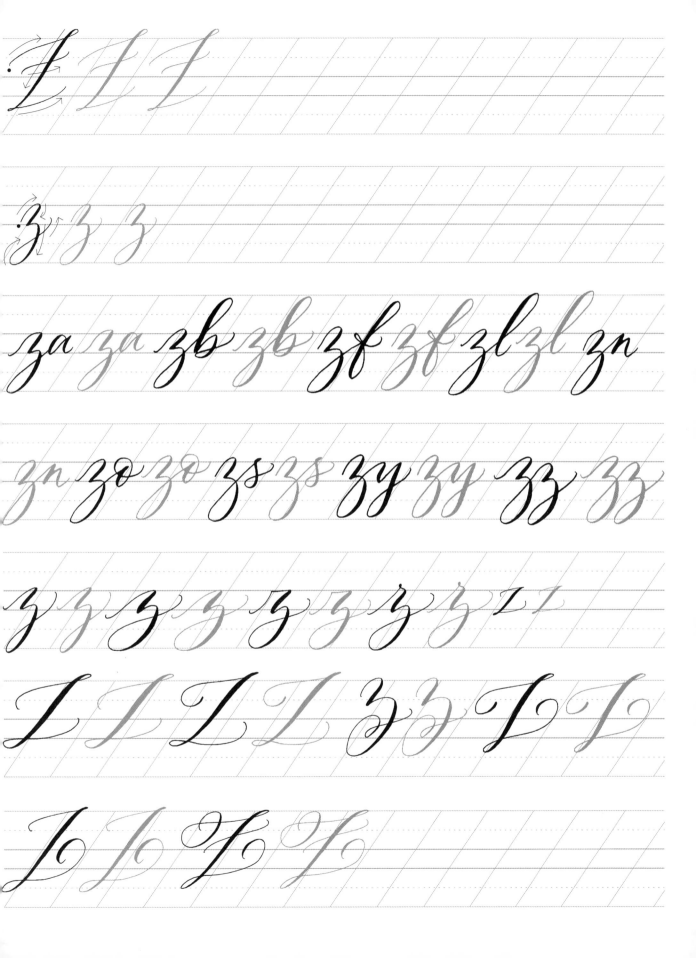

CONFIDENCE WITH SCALE

One of the key identities of 'modern' calligraphy is the non-adherence to set size and scale. You have the understanding of how letters should be and the associated proportions, but a modern feel is created by a freedom and variation of this scale. It's something that's hard to teach as there's not a set formula, such as every other letter is larger or so on. It's something that you just play with to find a bounce and balance and rhythm. This exercise is about practising letterforms increasing and decreasing in size, so you feel confident with making the same shapes at different scales, which will help when you start putting it all together.

ddddddd

eeeee

fffff

ggggg

hhhhh

iiiiii

jjjjj

kkkkk

lllll

mmmmm

nnnnn

ooOoo

ppppp qqqqq

vvvvr sssss

xtttt uuuuu

vvvvv *wwwww*

xxxxx *yyyyy*

zzzzz

NOW IT'S YOUR TURN...

WORDS

By now you'll have put in plenty of time practising the basics – your individual letterforms and the basic shapes that were the building blocks for most of what you've been doing. Well done! I promise that putting in all that effort was worthwhile, because now – when you come to put it all together to make words – it should feel pretty straightforward. You should be confident enough to handle any combination of letterforms together as you've had plenty of practice.

Once you've got into the swing of writing words, you can start to play a little more with developing your style, both with the pace and rhythm of your lettering and with decorative flourishes.

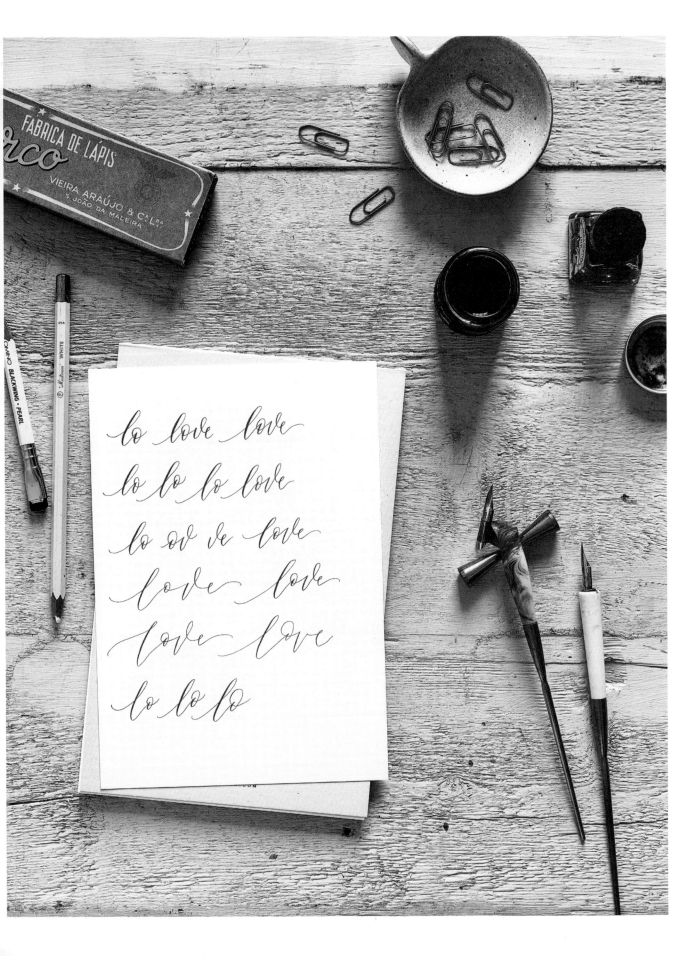

When starting out you might just want to practise some words to help get you underway. There are a couple of ways to start: begin by practising some three-letter words, then four- and five-letter words and then move on; or you pick a word, and then break it down into smaller groups of two to three letters and practise each group before bringing it all together.

Think about the size and scale from the previous exercise. Double letters are great for playing with this.

When you begin creating words, you'll start to notice that some letters join naturally to create a single letterform (glyph) with a ligature. For example, instead of writing two separate 'tt', combine them to make a single glyph. There are some examples below, so you can see how this works. You'll notice if you tried to write the letters individually they may awkwardly bump together, but when combined they work in a much more visually pleasing way.

NOW IT'S YOUR TURN...

dog dog dog dog dog

love love love love

hello hello hello hello

STYLE

EXPERIMENTING AND DEVELOPING YOUR STYLE

I'm not a traditionally taught copperplate scribe, but looking at traditional copperplate has helped me to develop my calligraphy style. We've mostly been looking at one of my calligraphy styles, but how do you create your own style, without it just looking like handwriting and losing the calligraphic quality?

This is where you can start to have a bit of fun, and also become more aware of how your hand is drawn to making certain forms.

I've created some examples for you to see, and there is space for you to try things for yourself. Try and see what happens when you start to play with scale by extending or condensing the letters: over-exaggerate the ascenders and descenders, or over-extend the joins between the letters. Work loosely and a little faster – keeping control but being looser – and see what happens to your lettering; keep adding and relieving pressure but be a little lighter and more fluid. This is where you can really start to play with what feels natural for you. Try a variety of nibs; I find that different nibs have different personalities for me, some nibs always make me work in a more 'formal' way, with additional flourishes and a slower, more considered style. Some suggest more scrawly haphazard forms, and others a loose, light feel.

What happens when you write with different nibs, do you feel your style change with the flexibility and feel of the nib?

almost almost almost

almost almost almost

almost almost

almost almost

almost almost

Try writing a word and seeing how you
can vary its style, feeling and character...

almost almost

almost almost

almost almost

almost

Try varying the speed at which you work. What do your letters look like when you work faster and with lighter pressure, versus with when you work slowly and a little firmer? What happens when you elongate your connecting strokes? What happens when you elongate your ascenders and descenders? Experiment and play with creating tighter more formal styles as well as looser more relaxed ones.

MIX AND MATCH

In typography and when using fonts, we can create a different hierarchy and importance of type by adding weight or changing angles, so using bold or italics, or by increasing the point size.

You can also create differentiation with calligraphy. Menus are a great way to practise this, and to create different lettering, because you have to create something legible, that communicates important information, and is clearly in sections. Here are a few different style examples of this.

Pick a dish and try and letter it in a few different styles, from small and block capitals to flowing and fluid calligraphy, to see how you can create different looks.

MENU

Now put it all together and write out a dreamy menu, using contrasting styles by picking two from the previous page.

risotto al limone

Risotto al Limone

risotto al limone

risotto al limone

risotto al limone

risotto al limone

Risotto al Limone

RISOTTO AL LIMONE

MIX AND MATCH

Try out some different styles below

SMALL CAPS - YOUR BLOCK CAPITALS

ECLECTIC CAPITALS - A FREER VERSION OF CAPITALS,
FEEL FREE TO MIX LOWER AND UPPERCASE TO GIVE
A MORE ECLECTIC FEELING

MORE FORMAL FEELING CALLIGRAPHY
WITH LESS BOUNCE AND MOVEMENT

LOOSE, MORE EXPRESSIVE
AND FREE CALLIGRAPHY

PERFECT PAIRINGS

You can now try writing out some menu items,
using a combination of styles you've been
practising. Think about how someone is going
to read this information, how can you make it
look beautiful but so it is still easy to understand
the relevant information fairly quickly.

NOW IT'S YOUR TURN...

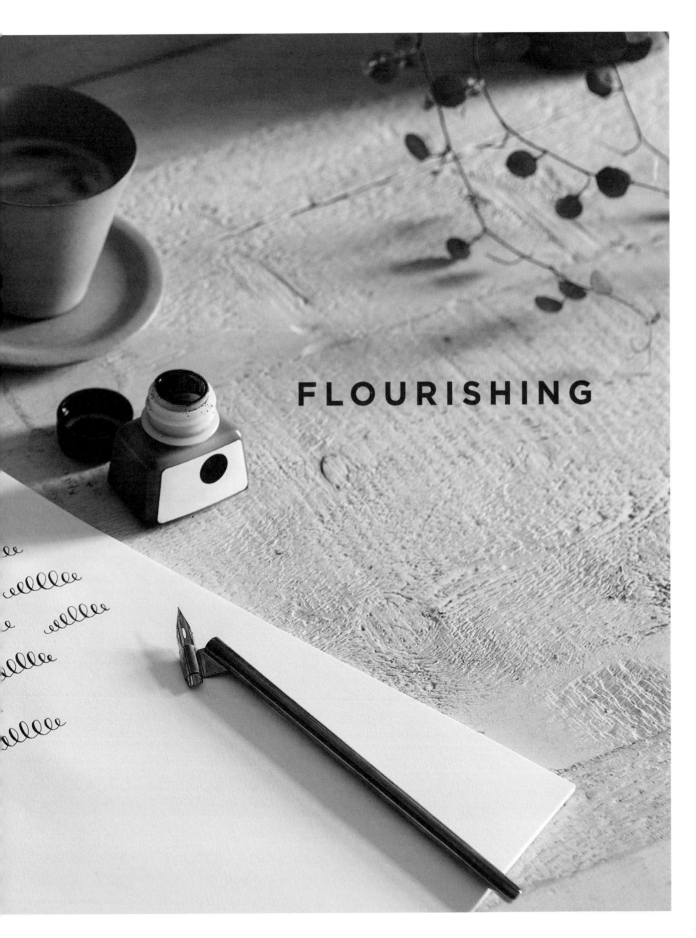

FLOURISHING

BASIC DRILLS

Practising flourishes is super enjoyable, it's great for getting you used to flowing around shapes and it's so easy to get lost in the process. This is also where you really learn to smooth your shapes out; the more you repeat these, the more your muscle memory will develop and you'll get used to making these shapes.

These are my favourite calligraphy practice exercises, and a brilliant way of quietening a busy mind, taking a break and doing something super relaxing. If you ever need a bit of calm, take yourself off and do some of these drills! It works a treat!

HOW / WHAT / WHY?

Flourishing is how you add drama to your letters or make them more decorative. Getting confident with flourishing can certainly take time. Part of that is about being confident with making the shapes and also knowing where to make them.

The way you use flourishes also changes the nature and feel of your work. You might want to create something super ornate that feels lavish and extravagant, or you might just want to gracefully extend some letters to make them feel more decorative but in a more minimal style. The great thing about flourishing is you can do as much or as little of it as you like!

Let's start by practising some basic flourish drills to get your hand used to making the forms. Once you've become more confident with these shapes, you can start to look at how and where you add flourishes to your work.

Use these blank shapes to fill with flourishes. Work on making beautiful smooth shapes that fill a space but remain balanced and consistent. Your shape should be the same at whatever size and try to keep space between forms balanced as well. This is really going to help your rhythm and flow.

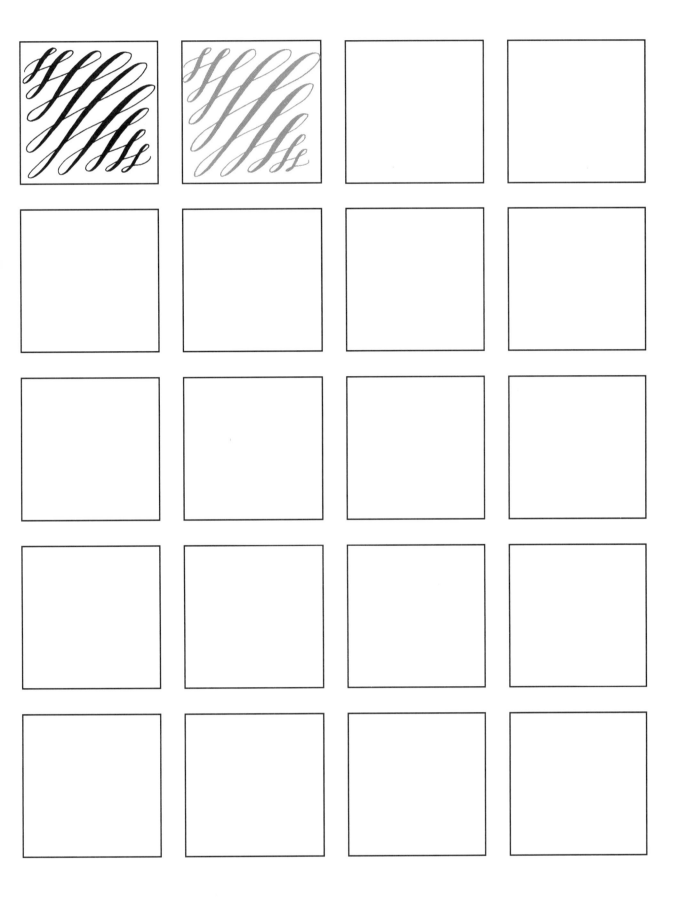

LOOK AT LETTERS

Flourishing is where we inject a little extra style into our letters, looking for ways to elongate strokes and add more decorative extensions to letters. Letters that have ascenders or descenders are perfect opportunities for this, alongside those that might have crossbars, such as capital T or A.

Pick a letter and see how many ways you can add variation to decorate and extend the strokes.

NOW IT'S YOUR TURN...

Here are some letterforms that are easy to add flourishes to. Try adding different flourish options with a pencil and seeing what you can do.

q q q q q q

q q q q q q

h h h h h h

l l l l l l

l l l l l l

y y y y y y

COMPOSITION

Write out a quote or phrase you'd like to use. By writing it out you will be able to see what it looks like and then start adding flourishes and playing with the layout, size and scale. Try to balance your work so that you don't always make the same shape flourishes in the same places. Think about the overall effect and using opposing shapes to balance it out. If you have something at the bottom of your design then maybe add something at the top.

Look at the negative space and the shape it makes as well as the letters themselves. You can use flourishes to fill this space. If it helps, start in pencil to lightly mark out where your base line would sit, or to sketch out a shape if you want to make your lettering sit inside a set form.

Examine the words you are working with and notice which parts want to stand out more. You can always make these larger or put them on a different line to make them more dramatic.

Try and balance out elements with equal design flourishes on opposing sides.

you are like sunshine and bring me nothing but joy

Try not to flourish all your letters in the same way.

Think about the negative space between letters and words as well as the words themselves.

Think about where you might want to add drama, or keep things simple.

You can work on your composition by writing your piece out as plain calligraphy. Then experiment with adding decorative elements in pencil.

Think about the look you want to create; do you want the lettering to fill a particular shape; do you want it to be loose and expressive; or more ornate and decorative?

you are like sunshine and bring me nothing but joy

NOW IT'S YOUR TURN...

You are like Sunshine & bring me nothing but joy

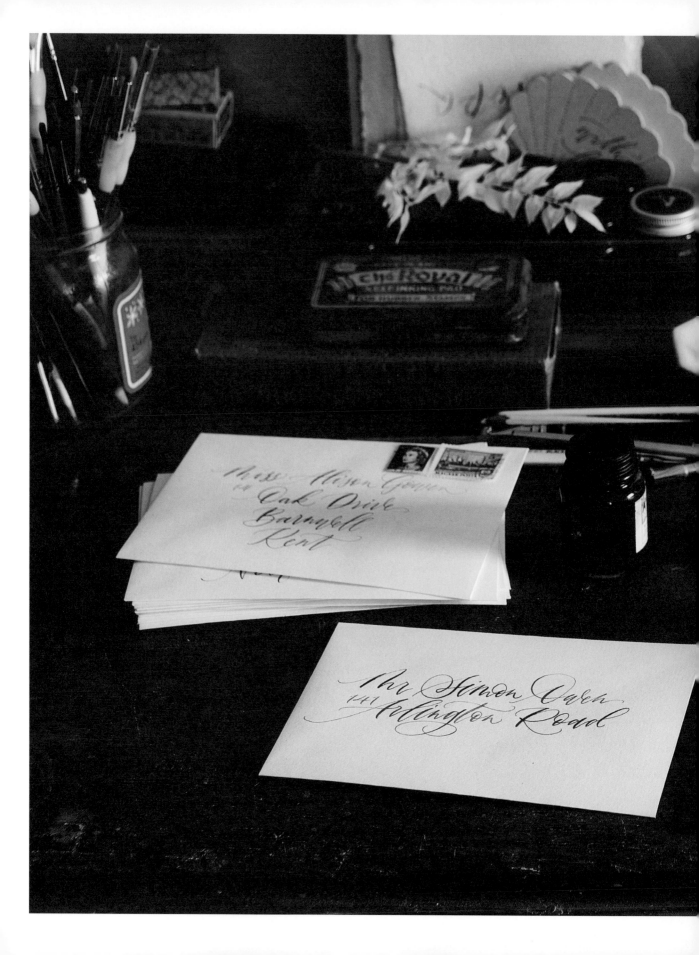

DECORATIVE ELEMENTS

DECORATIVE DRAWING

Working with pen and ink doesn't have to be just about lettering – you can also create all kinds of decorative elements with your pen. There are some wonderful examples of historical penmanship, creating illustrations using incredible flourishes, so I'd certainly urge you to check these out.

I've included some examples here as inspiration that you can trace, but you can try experimenting with some ideas of your own as well.

Think about composition and balance; it's always a good idea if you have something striking and complex to balance it out on an opposing side with a smaller, simpler detail.

NOW IT'S YOUR TURN...

A good starting point is to create a basic line and then build onto this. So draw a simple but elegant line and then look at how you can add to it to make it more decorative. Try creating some simple lines below and then see what happens when you add a little more detail. There's space to have a go alongside my examples.

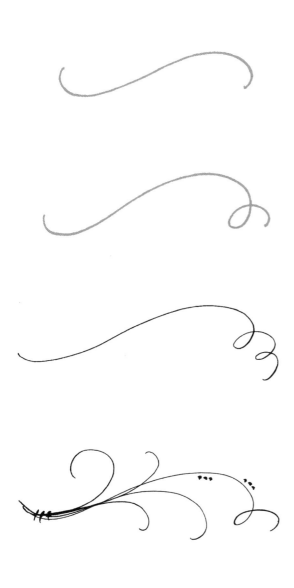
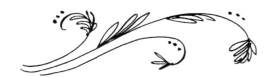

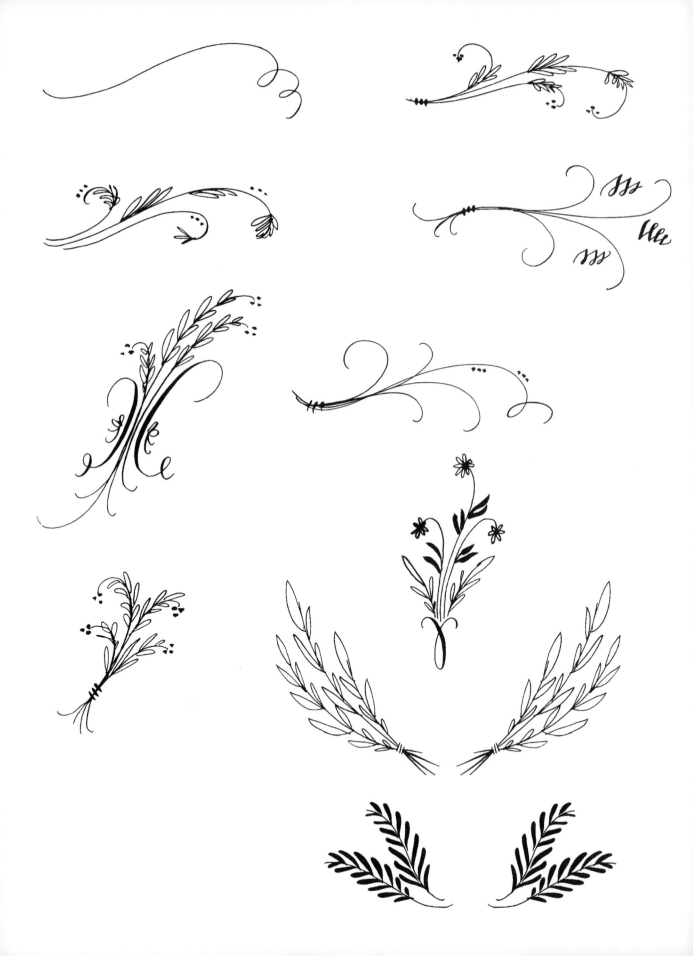

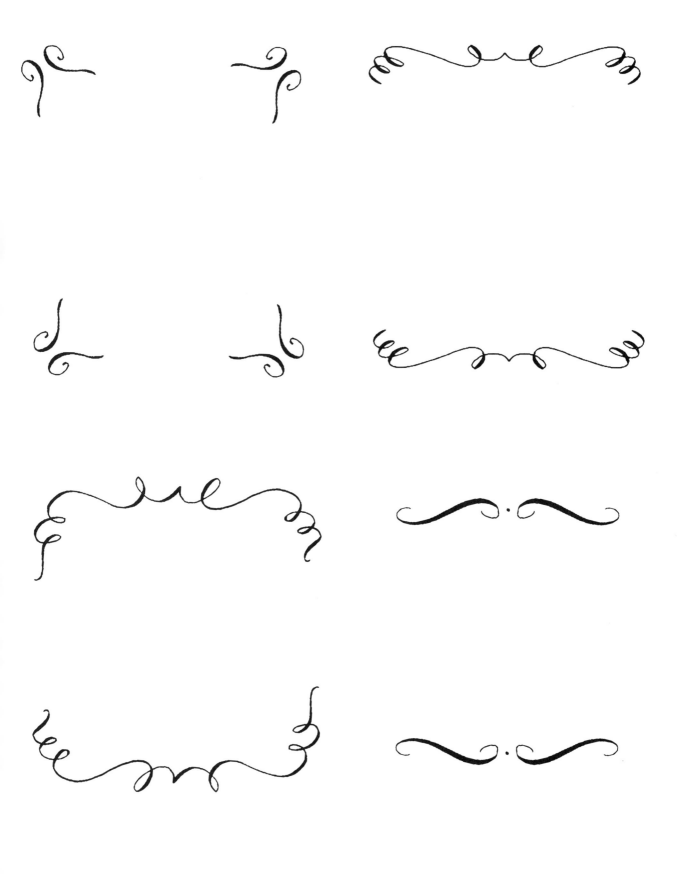

CREATE YOUR OWN WREATHS & DECORATIVE ELEMENTS

NOW IT'S YOUR TURN...

Using these shapes as a guide, create your own wreaths and decorative elements. You can create full wreaths or just use part of the shape. Think about balancing out your elements; if there's something bolder at the top, balance it out with something smaller at the bottom.

OBSERVATIONAL DRAWING

Dip pen and ink has long been used as a medium for drawing. I've always loved Andy Warhol's early illustration work for advertising in pen and ink, as well as Jean Cocteau's ink drawings. Quentin Blake is probably one of the most well-known illustrators of our time, who famously works in pen and ink. What all of these artists' work has in common is the loose, scrawly drawing quality that comes with working with dip pen and ink. It's a great medium to work with to create loose mark-making and flowing drawings, creating simple but effective images.

You may want to add more illustrative elements to your work, which can be through flourishes and creating illustrations from flourishes. Or you can use your pen and ink to draw with – this is a great way for you to build confidence with working with pen and ink, because drawing in this way requires a light touch. Often the best drawing is quick and gestural mark-making, capturing the essence of something but without being overly fussy about too much of the detail.

Try your hand at drawing from life; you could draw flowers, or some fruit or vegetables, or just draw your tools. The garden is great for inspiration, just pick a few flowers and a bit of foliage, or look for fruit or vegetables you might have at home. Put together a little arrangement and then, using your pen and ink, draw what's in front of you. Sketch out loosely what you see, trying to capture the essence of what's there in simple marks – looking at the shapes and structure but simplifying them.

PUTTING PEN TO PAPER

To get started, just think of it as making visual notes with your pen and ink. Use your pen just to jot down the basic forms that you can see, capturing the essence or sense of a shape with a few loose lines. The key is to work freely without worrying about something being right or wrong, just moving over the paper making marks and getting a sense of what is there. This exercise is all about looking and capturing basic forms. This is really going to help you to get comfortable working with your pen and ink, and being lighter on the page.

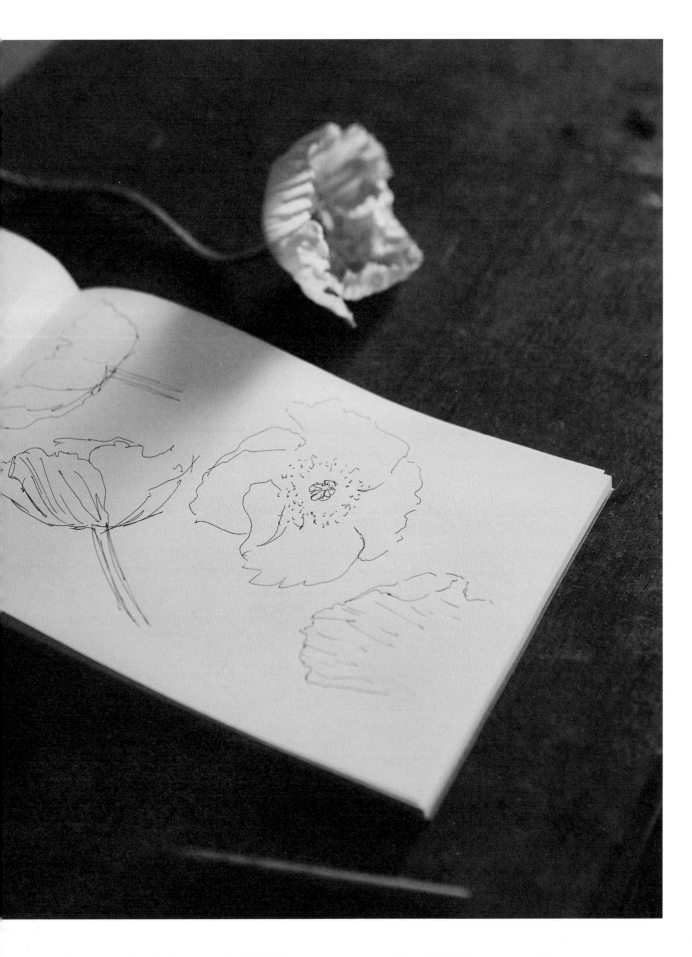

NOW IT'S YOUR TURN...

Pick some flowers or simple prompts
to draw and work loosely, trying
to pinpoint the main shapes you
can see and small details that will
reinforce the defining characteristics
of what you're trying to draw.

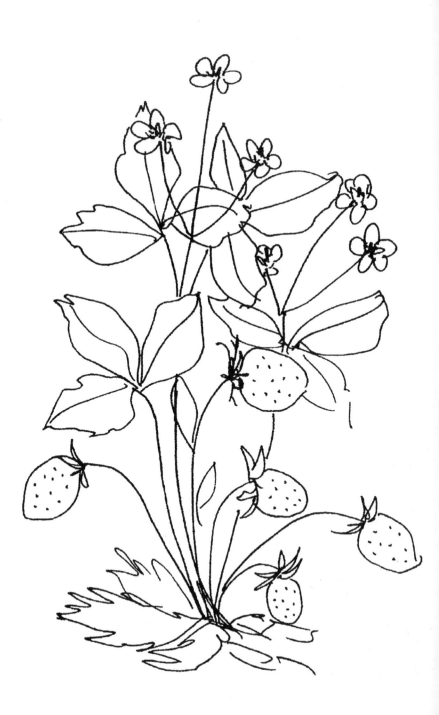

ADDING A LITTLE BIT OF INK

Adding decorative items to your work is a great way to add interest, and colour, too. You might be super confident with drawing, or a bit more hesitant, but the loose style of pen and ink drawing is pretty forgiving and will also introduce a bit more fun into your work. You can then use ink washes, felt pen, watercolours or pencil to add pops of colour to your illustration later.

These more dramatic borders are a great way of framing work, whether it's for a menu or a party invitation.

Here are some ideas for how you could use them, and space for you to create your own.

Save the Date

Emilia
& Samuel

8th July

2022

NOW IT'S YOUR TURN...

EMBELLISHING THE ORDINARY

Part of the joy of your new-found calligraphy skills is being able to use them at will. I like to have a bit of fun with them – it's not all about writing fancy envelopes and wedding invitations, you can write something beautiful on a scrap piece of notepaper with coffee stains on it.

This prompt is for you to enjoy yourself, so write out your shopping list in calligraphy. Then, if you're feeling a bit playful, try another version and make it as ornate as you can with flourishes so your mundane scribbled note becomes something to treasure.

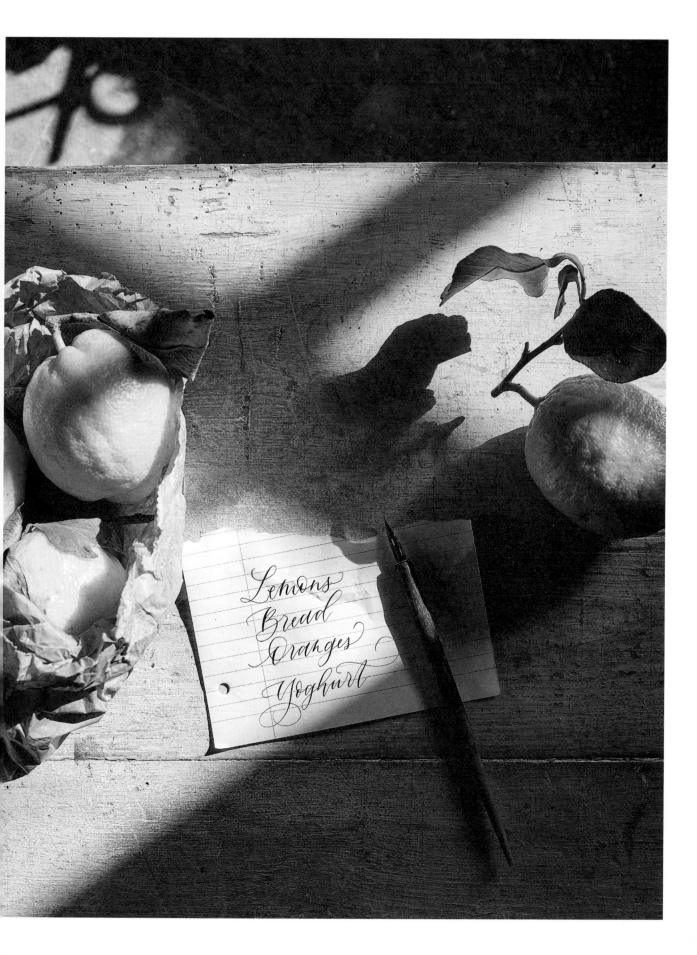

Eggs
Milk
Toilet Roll
Greek Yoghurt
Spaghetti
Broccoli
Cheddar

Eggs
Milk
Toilet Roll
Greek Yoghurt
Spaghetti
Broccoli
Cheddar

Start by writing your shopping list or a reminder to put the bins out. Write it so you know how the words look, then try and make it as decorative and elegant as possible.

GETTING FESTIVE

The holiday season is a great opportunity to practise your calligraphy skills, and to add some super personal touches, whether it's the place names on your Christmas table, a beautifully written menu, using an edible colouring on the Christmas cake, or for cards, envelopes, tags and wrap. There are so many ways to put your new skills to good use. Here are some words and phrases you might want to practise or use for inspiration.

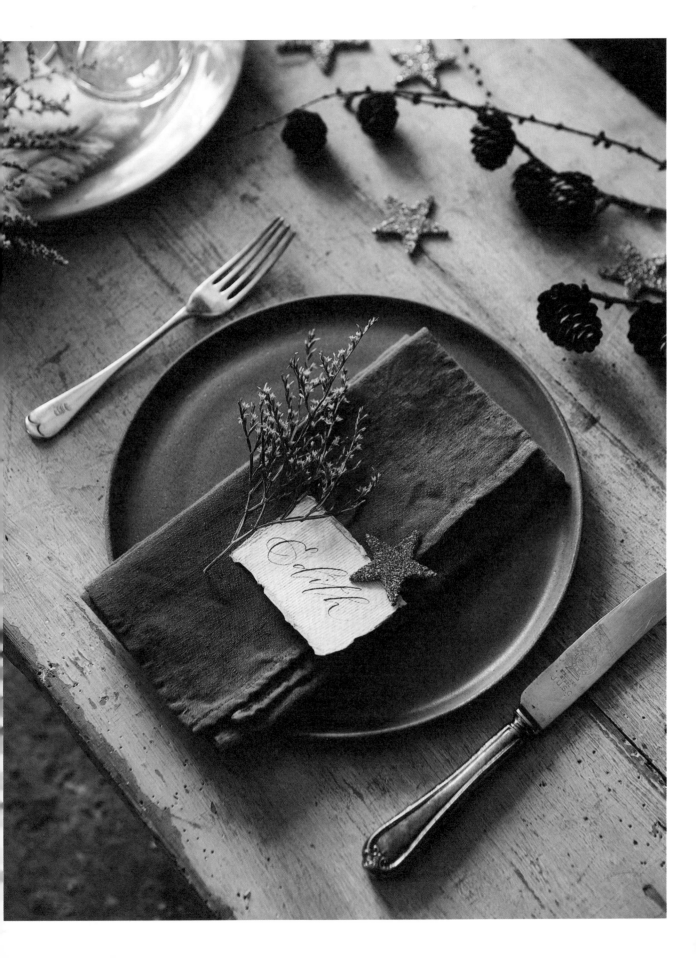

Merry
Christmas

Don't open
till 25th

No Peeking

Silent
Night

Joy to
the world

Joy to
the world

Happy
Holidays

THE PERFECT PARTY

People who come to my workshops often tell me they are starting calligraphy to work on a wedding or party. From on-the-day items such as place names, menus, table plans or hand-painted signs to the initial invitations, there are lots of ways to introduce calligraphy into your event. Here are some tips on how to layout your work and some useful bits to practise, too.

It's a good idea to print out any names or words you are looking to centre and to mark the centre point. The simplest way is to set the paragraph settings on your computer document to centred (as opposed to left or right aligned) and then draw a straight line down the middle in pencil. You can now see which part of the name or word is going to need to be in the middle. You can practise writing out the word first to see how it looks at the scale that you work, and this should help you get an idea of where you'll need to start and finish in order for it to be centred.

When putting in guides, people are often tempted to mark a line across the middle of the paper they're writing on both horizontally and vertically. The thing to remember is that we normally write on the line, so if you then write on this marked horizontal line your letters will all be higher than the middle. Remember the 'x-height' of the letters (see page 13), and note that a point directly in the middle of the x-height is the point that would be in the middle of the page. So instead, draw the horizontal line as the lower line of the x-height so it is the line the letters are going to sit on.

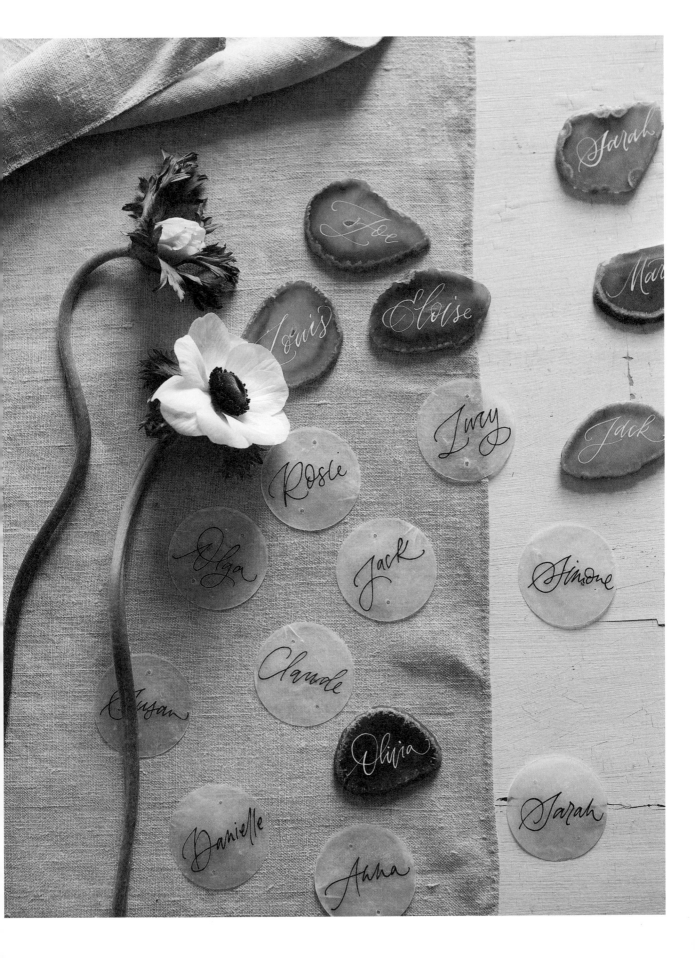

One of the important things to be aware of with items like place names is the proportions of your work and keeping something that looks balanced; it's not always about something being centred so much as the appearance of being centred.

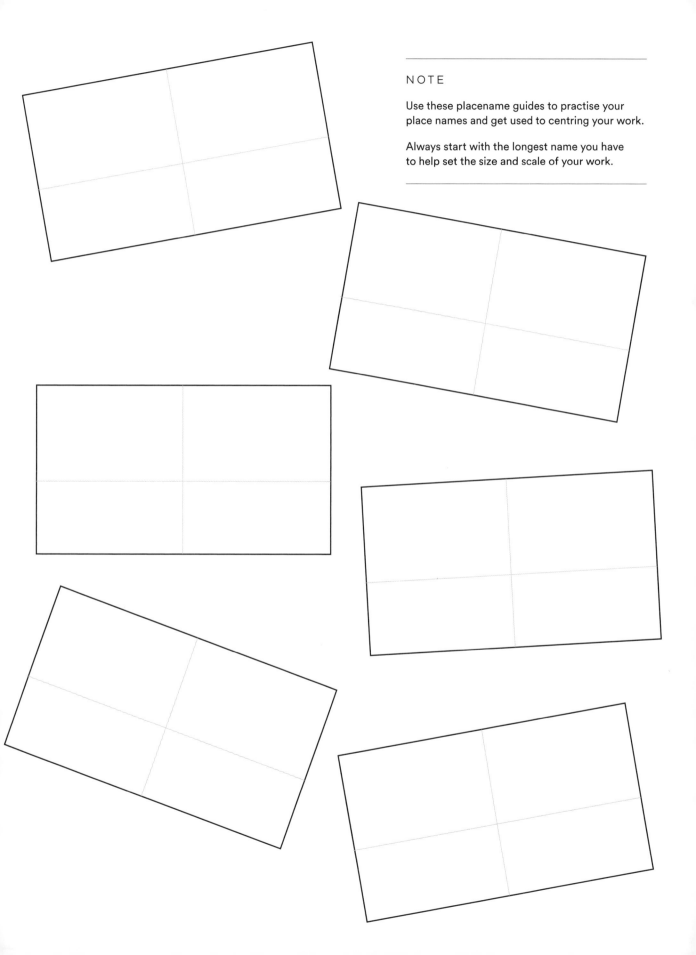

NOTE

Use these placename guides to practise your place names and get used to centring your work.

Always start with the longest name you have to help set the size and scale of your work.

to have
& to hold

to have
& to hold

Mrs Mrs

Mr

Mr

& &

& &

& &

love
love

Welcome

Welcome

NOW IT'S YOUR TURN...

You can use these guides to help you practise writing place names. Practise writing first names only as well as first and surnames.

ADDING SERIOUS STYLE AT HOME

One of the nice things about having calligraphy and lettering skills is that it's a great way to create finishing touches that make things feel really special. Maybe you're just having some drinks for friends at home – you can easily practise your skills by rustling up a quick drinks menu. You can create beautiful labels for jams (jellies) and preserves and home produce, or even just decant laundry detergent into a Kilner jar and write beautifully on that. There are so many places you can inject a little calligraphy magic into your home.

Try your hand at a little drinks menu; a loose style works brilliantly here as it looks pretty effortless and hurried but super chic!

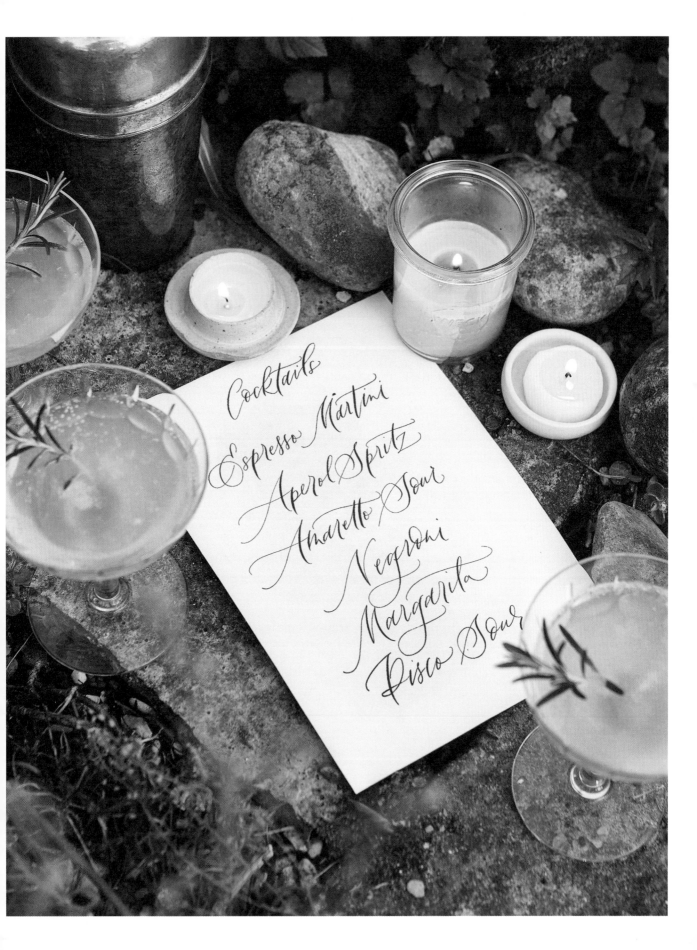

Cocktails

Espresso Martini

Aperol Spritz

Amaretto Sour

Negroni

Margarita

Pisco Sour

Espresso Martini

Aperol Spritz

Amaretto Sour

Old Fashioned

Whiskey Sour

Margarita

Cocktails

TAKING YOUR SKILLS OUTSIDE

Another brilliant opportunity for creating gorgeous finishing touches is in the garden, where there are lots of ways you can add style. There are all kinds of plant tags available, from wooden or slate name sticks to smarter copper and zinc, and you can letter on any of these. Whether you are potting up a gift for a friend or making the herb garden of dreams, these are a super easy way of making things look extra special. Picking some flowers for a bouquet? Try writing on paper and using that as the wrap for them.

On the following pages you can find some plant names to practise and some tag shapes to work.

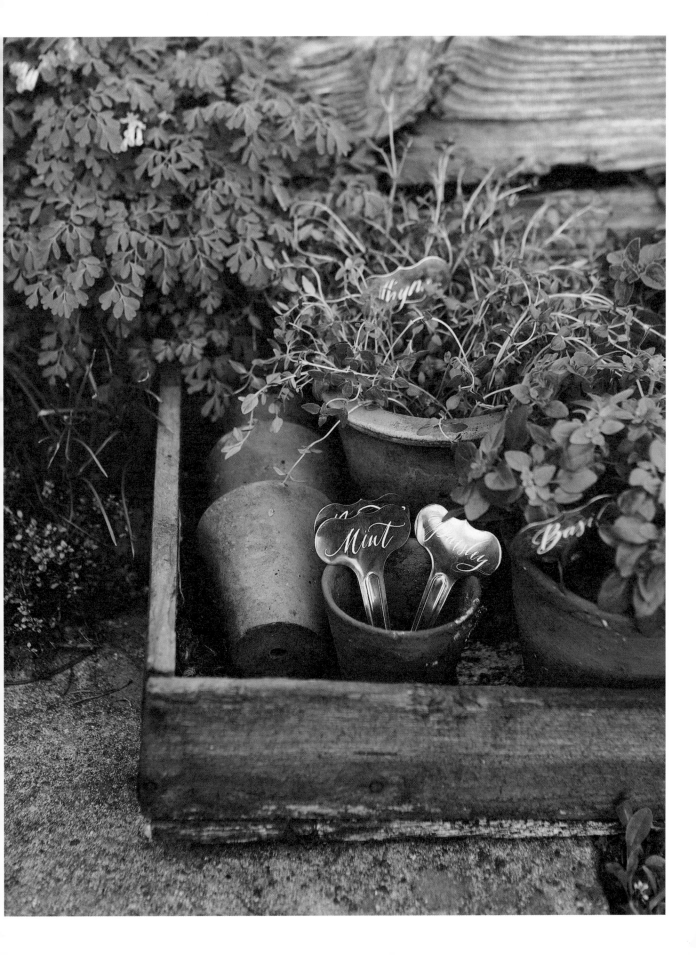

Radish Onions Lettuce

Rose Clematis Honeysuckle

Parsley Thyme Sage

Basil Mint Chives

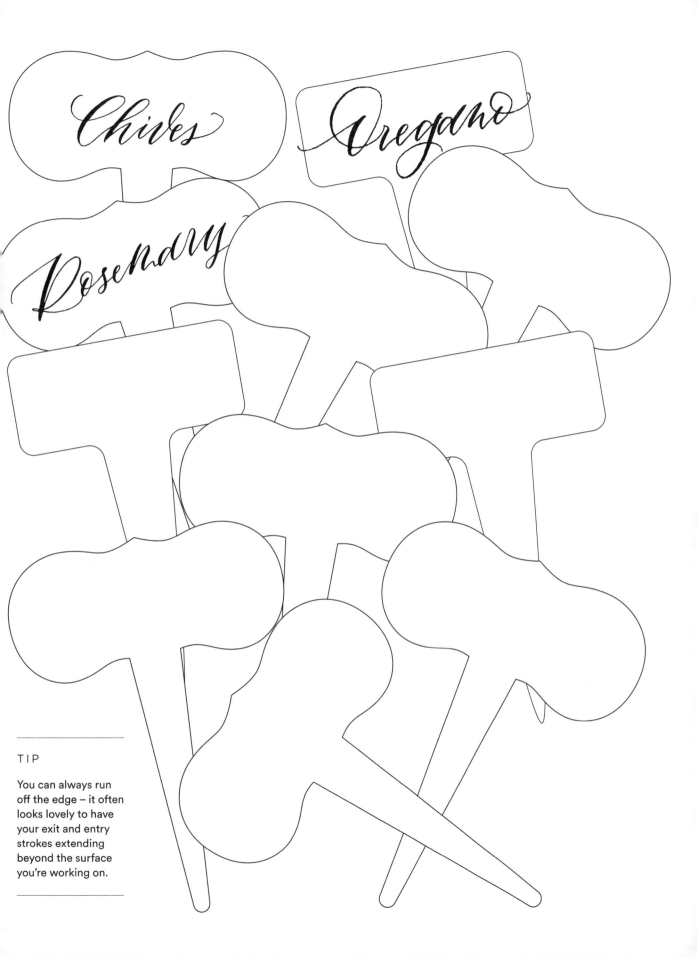

Chives

Oregano

Rosemary

TIP

You can always run off the edge – it often looks lovely to have your exit and entry strokes extending beyond the surface you're working on.

A LETTER TO...

Working as a professional calligrapher, one of the most common jobs you get asked to do is envelope addressing. There is something so very special about receiving beautiful post – the novelty of an envelope in a different shade peeking out never wears off. A beautifully written address is always a joy to receive.

How do you go about it? Here are some tips on how to layout your envelope in a few different ways.

First things first though, it's always a good idea to type the address out on the computer and centre it, then rule a line down the centre – you can do this on the computer before printing or just in pencil after if you're not sure how. Taking the time do this is always worth it as you'll know what should be where when you come to write your address out.

Mr Jack Monroe
114 Main Street
Winchester, Hampshire
SO16 5MX

Mr Oliver Stone
The Hall
Great Langton
Leicestershire

Jack Benet
the Biscuit Factory
Whitechapel
London
E5 7QT

Miss
17 Russell
Bloomsbury
London
W12 1NR

Miss Olga Martin
24 Chesterton Road
Cambridge
CB6 7LW

Stephens
TAPER WAX

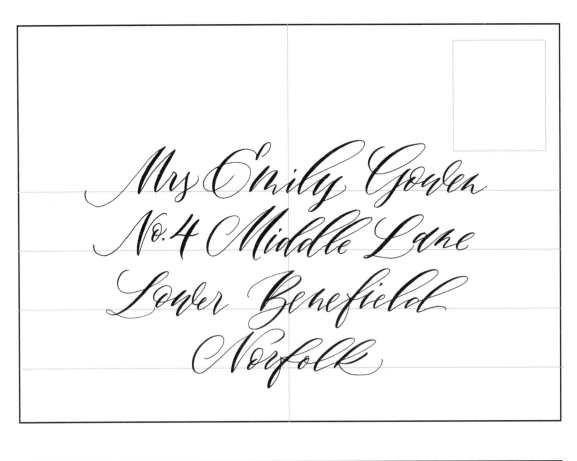

Mrs Emily Gowen
No.4 Middle Lane
Lower Benefield
Norfolk

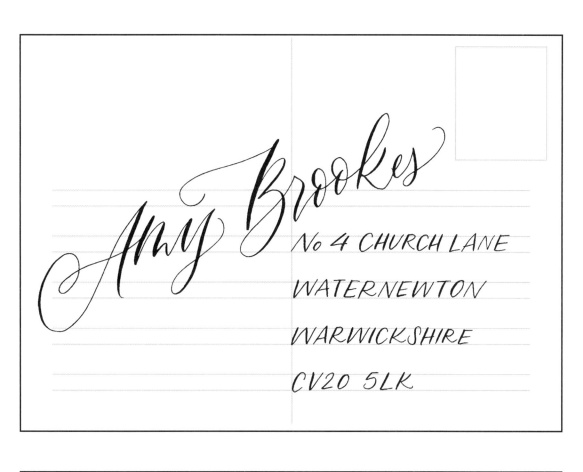

Amy Brookes

No 4 CHURCH LANE

WATERNEWTON

WARWICKSHIRE

CV20 5LK

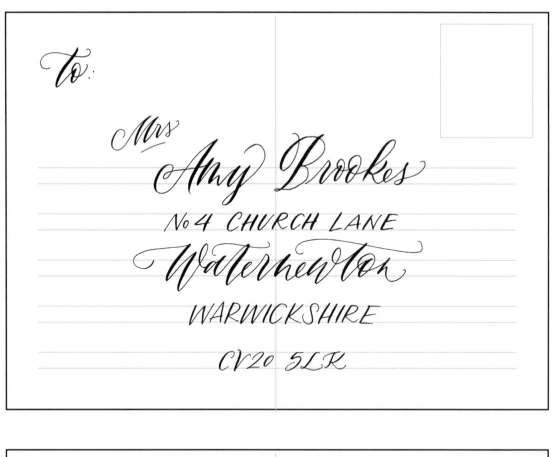

to:

Mrs
Amy Brookes
No 4 CHURCH LANE
Waternewton
WARWICKSHIRE

CV20 5LR

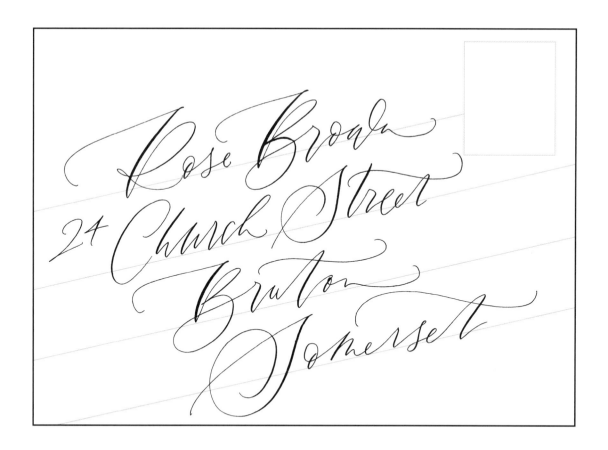

Rose Brown
24 Church Street
Bruton
Somerset

IT'S A GIFT...

Gift wrapping paper and gift tags with
a touch of calligraphy are always going
to feel even more personal and special to
anyone receiving them. There are so many
options – I've given you some tag shapes
to practise with, so you can work within
these templates or extend your entry and
exit strokes beyond the template and add
in some flourishes, too.

You can also buy plain brown kraft paper,
and write on it directly to create your own
gift wrapping paper, just use pencil lines
to rule the space equally.

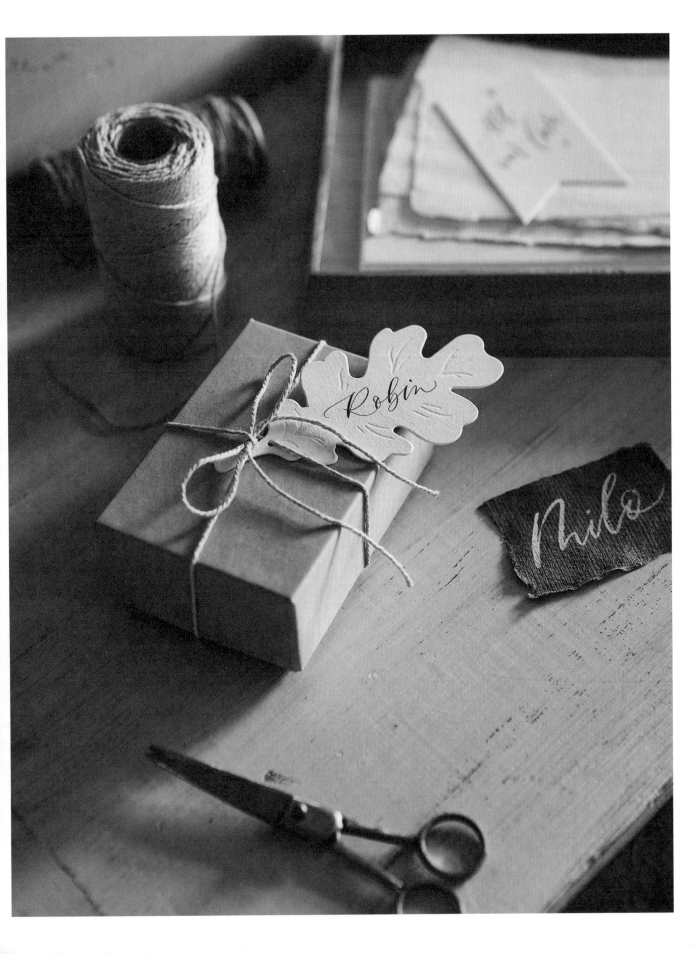

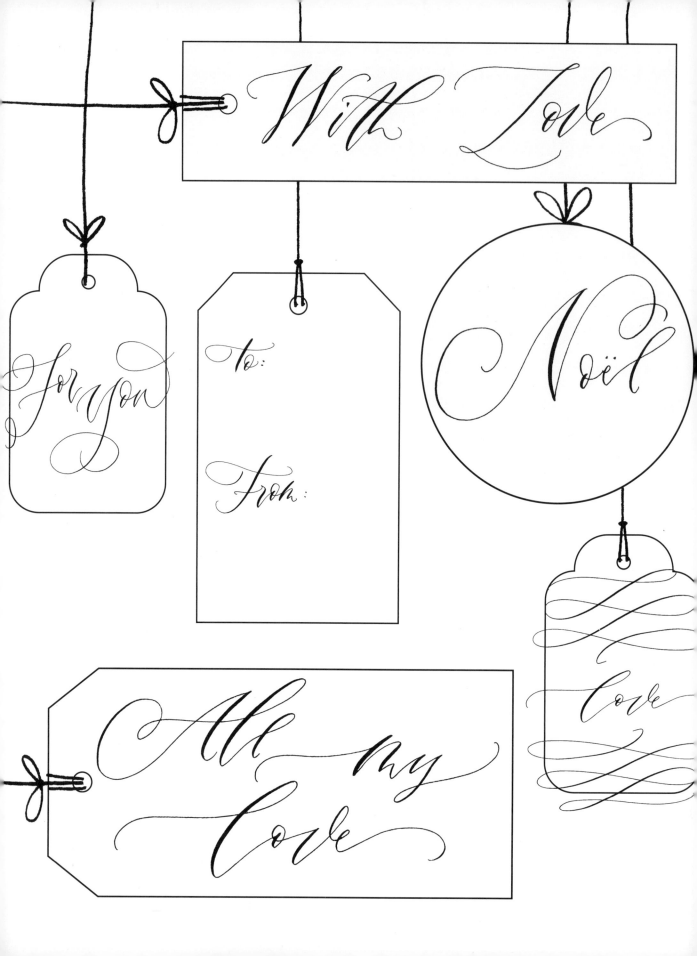

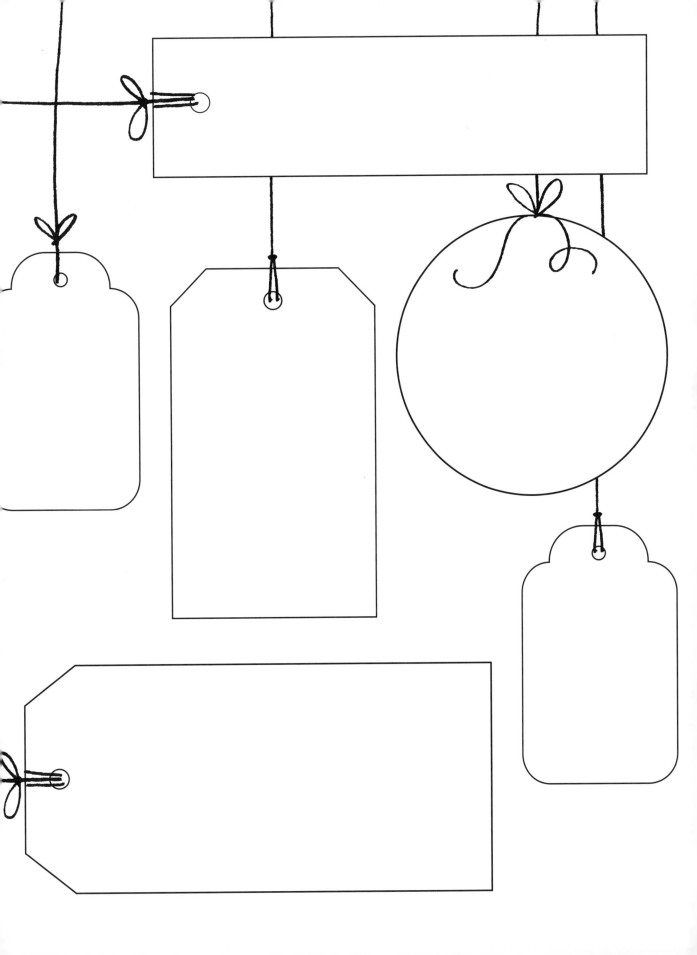

Wishing you a very Merry Christmas
Wishing you a very Merry Christmas
Wishing you a very Merry Christmas
Wishing you a very Merry Christmas
Wishing you a very Merry Christmas
Wishing you a very Merry Christmas
Wishing you a very Merry Christmas
Wishing you a very Merry Christmas

FREE AND EASY

Now you've built up your calligraphy skills, you can always turn your hand to a bit of brush lettering. You can use a paintbrush and ink (I like Winsor & Newton drawing inks) or a brush pen. You can base your letter shapes around your calligraphy letters, but the beauty of brush lettering is you can be even more loose and free. You won't be able to make such controlled forms – especially with paintbrush and ink – so you can feel free to embrace the mess and mishap, and create your own style that has much more freedom.

Enjoy the quality of the marks you can make with the brush, the inky splatters, the missed shapes and create something even more organic and haphazard. I've given you some practice exercises on the following pages to get you used to mark making with the brush and ink. Once you've done these you can go back and practise some of the past exercises with your new brush lettering style and as before you can either work in this book or on your own practice paper. Brush lettering is great for creating wrapping papers and bold tags, or you could mix it with calligraphy when addressing envelopes.

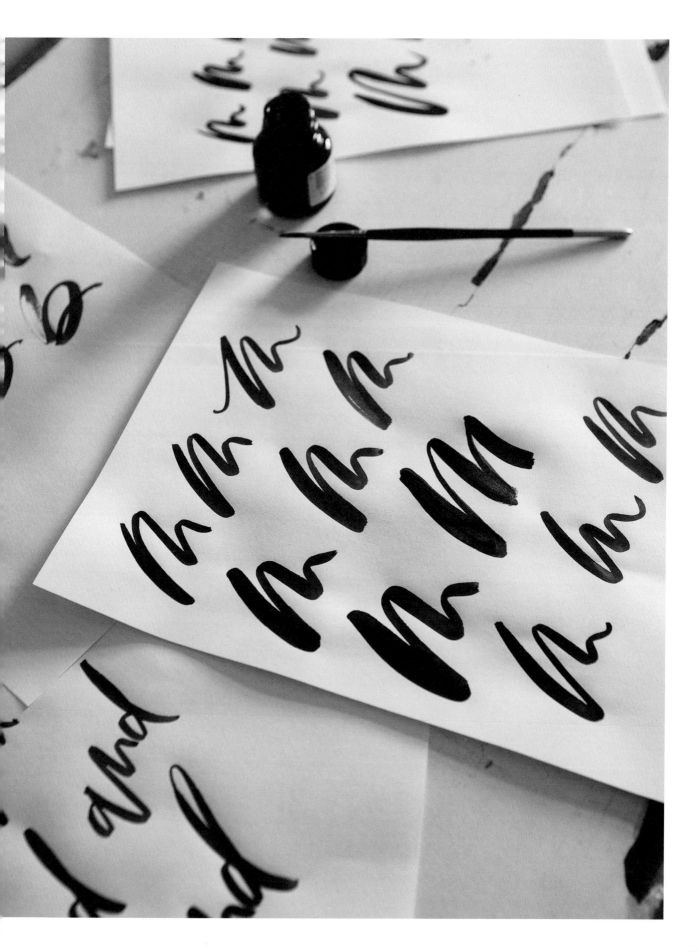

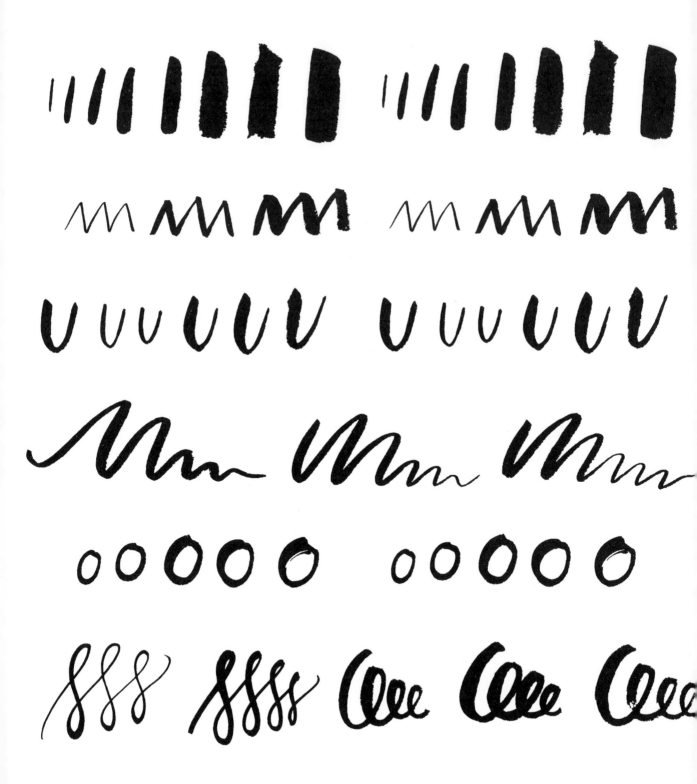

NOW IT'S YOUR TURN...

Try to practise getting a really good
range of widths of stroke using one
brush. Embrace the qualities of the brush
stroke and parts where the line breaks.
It's not going to be perfect but that's
part of the charm.

A B C D E
F G H I J K
L M N O P Q
R S O T U
V W X Y Z

a b c d e f g h i j k l m n
o p q r s t u v w x y z

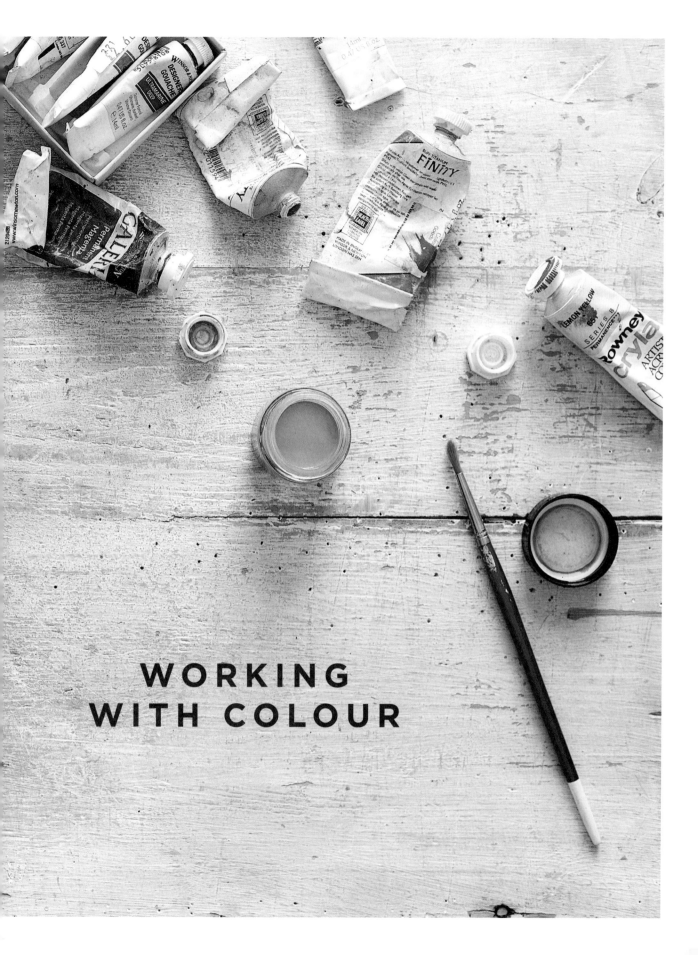

WORKING
WITH COLOUR

MIXING COLOURS

CONFIDENCE WITH COLOUR

I often forget that not everyone is used to working with mixing colours, because I've spent my entire life mixing paints and inks. Mixing inks is a great way to get just the colour you'd like for a project, and it's easy and fun. I've set out across the next few pages some suggested seasonal palettes for you to try and mix; you might not want to try all of the colours, but pick some that you like and have a go at mixing your own ink and see what happens. Once you start mixing you can experiment and put together your own ink store.

HOW TO MIX COLOURS

Even if you already know how to mix inks, I've included it here as a refresher for anyone who hasn't done it for a while.

Mixing colour inks is a great way to cheaply and easily create a range of totally custom ink shades. I tend to work with gouache or acrylic paints to create inks. Gouache are my favourite as they are lovely and opaque to work with so will show up brilliantly on darker colour papers.

You don't need to buy every colour available in your local art shop. A good basic selection will enable you to mix a ton of great colours!

I'm going to summarize the basics, and then make some suggestions as to what you might want to buy.

Primary colours
There are three primary colours – Red, Yellow and Blue – which are the colours that can't be created by mixing other colours. These are our base colours.

Secondary colours
These are the colours that we can mix by combining two primary colours. Secondary colours are Orange, Green and Violet.

Tertiary colours
These are created by mixing secondary and primary colours. Tertiary colours are Yellow-Orange, Red-Orange, Red-Purple, Blue-Purple, Yellow-Green and Blue-Green.

TINTING

Tinting is where you alter the colour by making it lighter with the addition of white.

SHADING

This is where you alter the shade of a colour with the addition of black.

SUGGESTED BASICS

To get started I'd recommend you get a range of colours you can use to mix a really great spectrum of your own inks. A beginner's set might be a great way to start because they are normally pretty affordable; you can always top up with a few more solo tubes as and when you need.

I'd recommend getting:
Yellow, Red, Blue, Green, Purple, Black and White

I'd also recommend getting a large tube of white, as this is the colour you will ALWAYS use most of.

To mix ink colours you'll need some containers. There are lots of small glass jars available, typically the kind used for cosmetics are pretty easy to get hold of – the 15ml (½ fl oz) size are quite good for mixing colours, or you can use the larger 30ml (1 fl oz) size.

You're aiming to use around a pea or broad (fava) bean size amount of paint, topped up with cold water – it's best to use distilled water, as it's free of any impurities, you can buy it online easily and it's very inexpensive. You can use tap (faucet) water, but it is possible it may deteriorate over time.

Mix your desired paint colour, and then dilute with water till it resembles the texture of double (heavy) cream. Go easy when adding water, you can always add more but it's a pain to have to add more paint. A couple of drops of Gum Arabic will help the flow of the ink when using it, so add this when you're happy with the ink colour and consistency. Now you're good to go, so try it out and see how you get on.

TIPS

When mixing light shades, such as a pale pink, start with a pea-sized amount of white, then just add a tiny bit of red and see how it looks. You can add a little more red as desired, but if you start with a pea-sized amount of red you'll use up a ton of white trying to achieve the same result.

When adding black to darken a shade, be very cautious and only add very small amounts. Too much black can create a dirty looking shade, and you can easily ruin what might have been a near perfect colour.

On the following pages I've given you some colour suggestions for seasonal palettes. You can try and recreate some of these yourself or create your own seasonal palettes – there is space for you to swatch your ink, and for you to test out your colours and write with them. If you create something you love, make a note of what you used by the swatch so you can use it as a reference to mix it again.

Think of this as your mini ink library!

SPRING
PALETTE

MIX:

MIX:

MIX:

MIX:

MIX:

MIX:

SUMMER
PALETTE

MIX:

MIX:

MIX:

MIX:

MIX:

MIX:

AUTUMN
PALETTE

MIX:

MIX:

MIX:

MIX:

MIX:

MIX:

WINTER
PALETTE

MIX:

MIX:

MIX:

MIX:

MIX:

MIX:

CALLIGRAPHY APPRAISAL

LOOKING BACK AT HOW FAR YOU'VE COME!

One of the most satisfying things about learning calligraphy is looking at your work and seeing the visual journey of how you have developed and your work has improved. I always recommend keeping work to encourage you and get you to start looking at how much you improve and change over time.

I'd love you to use this book like that, so it's like a journal in which you can see a progression. Even if you trace some of the pages and keep some loose pages in it, it's all part of your journey. Think of this page as a snap shot; you can download a copy and keep filling it out to see how things change as your work progresses.

FAVOURITE MAJUSCULE

FAVOURITE MINUSCULE

FAVOURITE WORDS

FAVOURITE FLOURISHED LETTER

FAVOURITE FLOURISH SHAPE

LETTER YOU FIND HARDEST TO GET RIGHT

COMBINATION OF TWO LETTERS YOU NEED TO PRACTISE MORE

TROUBLESHOOTING

My ink is just blobbing on the page!
You might well be exerting too much pressure; if you press too firmly on the nib the tines will splay wide apart and all the ink will flood down in one go as opposed to slowly over time.

My pen feels scratchy
You might be pressing too hard – you don't want to be getting a lot of resistance from the surface of the paper you're working on. If you've been using the nib for a long time and it's now snagging or scratchy then it's probably more the case that you need a new nib.

My lines are wobbly
If you're starting out, don't worry – this is natural until you're really confident. It's easy to be wobbly when you are concentrating hard and doing something slowly, but the more confident and decisive your mark-making becomes, the smoother your lines.

I just drank a double shot of espresso and now my work is a bit off
So caffeine can totally mess with your work and control; some calligraphers find that they really can't drink coffee and work at all. If you find you're suddenly much wobblier than usual it might be that double shot you've just had. If it was an espresso martini, then I think I'd maybe leave the calligraphy for a while!

Why do I run out of ink so quickly?
When starting out, people often press a little firmer than they need to whilst getting familiar with the technique. The more practised you are the longer the ink will likely last. You also want to ensure that your nib is properly prepared so the ink is coating it, and that you are submerging the nib, including the vent hole, when you dip into your ink.

How many words should my ink last for?
There is no specific rule for this, it will depend on different factors, but the firmer you press the more ink will flow down, so you'll use it up more quickly.

My hand/arm hurts
Calligraphy shouldn't be painful – unless you stab yourself with your nib, which I certainly wouldn't recommend! If you are finding that your hand or arm is uncomfortable, it's probably because you are gripping too tightly or tensing and stiffening too much. You need to keep your arm and hand relaxed so they can move freely without tension, and make sure your movements aren't rigid.

Paper keeps getting stuck in my nib
If you're finding that you keep getting chunks of paper fibre stuck in your nib then this is normally a sign that you are pressing too hard. If you press too firmly your pen won't glide across the surface of the paper, and instead will catch and pick up some paper fibres.

I'm not getting any better
I don't believe this! I'm quite sure you are! Have a look at what you've done, and what your work looked like when you started. Try not to be frustrated if things aren't improving as quickly as you'd like. Stick with it. You're doing great!

My letters are really wet
This is normally another sign that you are putting too much pressure on the pen and setting too much ink down. The finesse of the technique is to create your thick strokes by exerting as little pressure as needed.

My thicks aren't in the right place
This is normally due to turning the nib to left or right as you work instead of keeping it face up. You should be moving the pen up and down, avoid moving the nib around.

GLOSSARY

Apex
The point at which two points meet, such as the top point of an A.

Ascender
The stem of the letterform that rises up from the body of the letter such as on b, d and h.

Baseline
The line (often imaginary) that the letters sit on. The lower line of the x-height.

Blotting
Blotting paper is a very absorbent paper and can be bought in a pad. You use it by laying it on top of the page of wet ink and then, without moving the paper, applying an even pressure over the surface to absorb any wet ink into the blotting paper.

Copperplate
A style of calligraphy script originating from the engraving of copper plates.

Connector stroke
The connector stroke is the stroke that connects two letterforms or 'glyphs'.

Counter
The space created inside a letter such as the space inside an a or a b. An 'open counter' is the space that isn't totally enclosed such as in a, u, or n.

Descender
The stem of the letterform that goes down from the body of the letter such as on the g, p and y.

Downstroke
The marks you make on a page going in a downwards motion.

Entry stroke
The stroke leading into a letterform.

Flange
This normally refers to the nib-holding part of an oblique penholder, which sticks out to the side. It is normally adjustable to fit numerous types of nib, fixed in place with either a screw or with pliers.

Flourish
A decorative stroke or series of additional decorate strokes.

Glyph
An individual letterform.

Gum Arabic
Used to modify the viscosity of ink, for helping the flow of ink from the nib. It can be bought as a powder to be mixed with water or as a liquid.

Hairline
Hairlines are super fine strokes. Upstrokes or those made with no pressure on the nib.

Letterform
The form your letter takes, also referred to as a 'glyph'.

Ligature
A ligature is where you have two letterforms or 'glyphs' that, when used next to each other might sit a little uncomfortably or knock into each other, so you create a combined form of the two instead.

Negative space
The space that is created around letters and words.

Majuscule
Majuscule are how calligraphers refer to 'uppercase' letters.

Minuscule
Minuscules are how calligraphers refer to lowercase letters – 'lowercase' and 'uppercase' are used in typesetting and typography.

Monoline
A single weight line – a monoline style would be one where you apply no pressure on any downstrokes so it all stays at the same thickness, or you could create it using a different type of pen, such as a felt tip, with no pressure.

Oblique pen
A penholder with an armature on the left-hand side that you fix the nib into, which angles your nib to aid writing on a slant. It is traditionally used for certain scripts such as copperplate.

Upstroke
The marks you make on the page going in an upwards motion.

Waistline
This is also the upper x-height line.

X-height
The height of a lowercase x – this is how we base the scale of the lettering and proportions.

RESOURCES

WHERE TO BUY SUPPLIES

Imogen Owen
imogenowen.com

Scribblers
scribblers.co.uk

Cornelissen
cornelissen.com

London Graphic Centre
londongraphics.co.uk

Fred Aldous
fredaldous.co.uk

Dick Blick
dickblick.com

John Neal Books
johnnealbooks.com

SPECIAL EDITION CUSTOM PENS

Tom's Studio
tomsstudio.co.uk

CALLIGRAPHERS WORTH CHECKING OUT ON INSTAGRAM

Traditional Calligraphers
Barbara Calzolari @barbaracalzolari

Modern Calligraphers
Alice Gabb @alicegabb

Megan Riera @meganriera

Betty Soldi @bettysoldi

Maybelle Imasa-stukuls @maybelleimasa

RECOMMENDED FURTHER STUDY ON TRADITIONAL COPPERPLATE

The Universal Penman
By George Bickham

Mastering Copperplate Calligraphy
By Eleanor Winters

ACKNOWLEDGEMENTS

One of the best things about my calligraphy and business journey has been the community of people that have come as part of this. They are the loveliest people; from the best clients, to the talented people I've been lucky to work with and to all the friends I've made along the way! A big thank you to everyone who has helped make this journey a total pleasure, whether you've signed up to do a course with me, or supported me and become a part of this adventure.

I'm super lucky to have my family who are incredibly supportive, always there when I need them and always encouraging me. I'm also privileged to have amazing friends who have been brilliant throughout a very challenging year when I would have struggled without them being so supportive, thank you all and especially Danielle, Rachel, Rachel, Jack, Tiff, Jess, Isla, Caroline, Emily, Simone and Kate and thank you to Nye for your hard work and of course Pippin.

Thanks to the lovely team at Quadrille, Harriet and Emily, and to the wonderful Yuki and Milly for their hard work bringing it all to life.

Publishing Director
Sarah Lavelle

Senior Commissioning Editor
Harriet Butt

Senior Designer Emily Lapworth

Photographer Yuki Sugiura

Stylist Milly Bruce

Head of Production Stephen Lang

Production Controller Katie Jarvis

Published in 2021 by Quadrille,
an imprint of Hardie Grant Publishing

Quadrille
52–54 Southwark Street
London SE1 1UN
quadrille.com

Cataloguing in Publication Data: a catalogue record
for this book is available from the British Library.

ISBN 978 178713 692 2

Printed in China

MIX
Paper from
responsible sources
FSC™ C020056

FSC
www.fsc.org

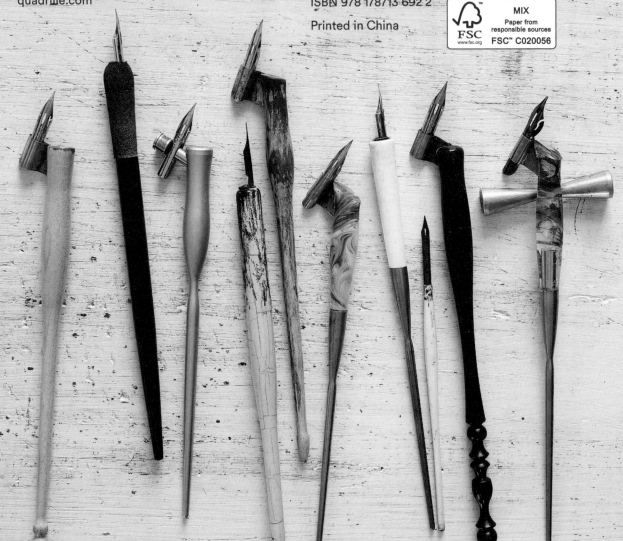